Postcard History Series

Black Hills and Badlands
in Vintage Postcards

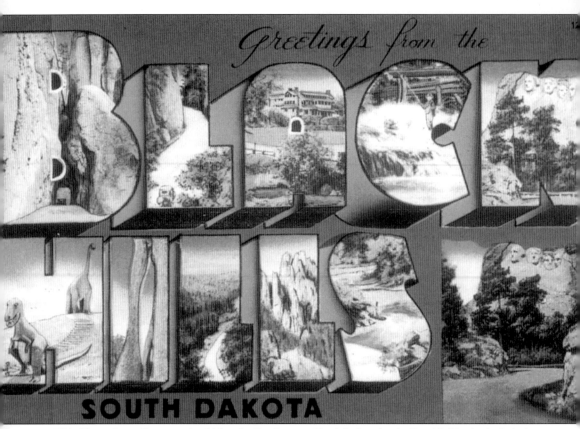

This "large-letter" postcard sold by the Rushmore Sinclair Service in Rapid City included views along the Needles Highway, the State Game Lodge, fishing streams, Mount Rushmore, and Dinosaur Park.

Front cover photograph courtesy of Bert Bell Studios.

POSTCARD HISTORY SERIES

Black Hills and Badlands
in Vintage Postcards

Richard L. Popp

Copyright © 2002 by Richard L. Popp
ISBN 0-7385-1964-2

Published by Arcadia Publishing,
an imprint of Tempus Publishing, Inc.
3047 N. Lincoln Ave., Suite 410
Chicago, IL 60657

Printed in Great Britain.

Library of Congress Catalog Card Number: 2002101227

For all general information contact Arcadia Publishing at:
Telephone 843-853-2070
Fax 843-853-0044
E-Mail sales@arcadiapublishing.com

For customer service and orders:
Toll-Free 1-888-313-2665

Visit us on the internet at http://www.arcadiapublishing.com

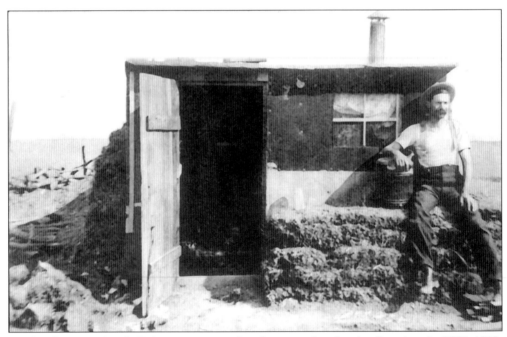

Much of western South Dakota was opened to homesteaders for the first time in 1907–1909, coinciding with the introduction of new inexpensive cameras and a boom in postcard production.

Contents

Introduction		7
1.	Wonders of Nature	9
2.	Getting There	21
3.	Mining	35
4.	Building Communities	45
5.	Farming and Ranching	65
6.	Creating Tourist Attractions	77
7.	Celebrating the Past	113
Select Bibliography		128

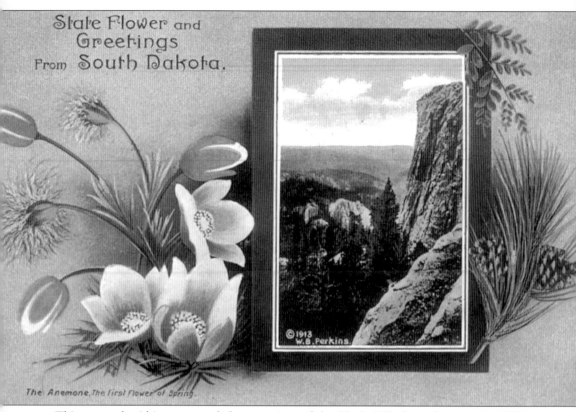

This postcard-within-a-postcard shows a view of the Black Hills from the summit of Harney Peak, from a photograph taken by Lead photographer W.B. Perkins.

INTRODUCTION

Postcard images are probably the way most Americans know the Black Hills. It seems as if everyone must have received a postcard of Mount Rushmore or Crazy Horse from vacationing friends, or has a few cards from their own trip stashed away. Many people are familiar with the unique scenery of the Badlands or the Needles, or the faces of Wild Bill Hickok or Calamity Jane, long before they visit.

Almost 100 years ago, visitors began sending picture postcards to friends back home, or gathered postcards into albums to show to family members when they returned. Local residents used these same postcards to send messages to friends and family near and far. Penny postcards were a cheap and dependable way to maintain contacts when telephone calls were expensive and unreliable, cameras required technical skills, and writing letters with stick pens was hard work.

Historians have largely neglected postcards as a documentary source because they are so familiar, so ubiquitous, that it is easy to take them for granted. Historians prefer rare photographs, articulate letters and diaries, or the elusive fact buried in the fine print of a newspaper, to the mundane, commonplace stories told by postcards. But it is the very ordinariness of postcards that makes them important to history. They contain the everyday stories of real people going about their normal, real lives.

Telling the history of the Black Hills through postcards has some difficulties. Postcard images are selected first by the photographers and publishers for aesthetic appeal and marketability. They are selected again by the purchaser or sender, based on personal taste and momentary impulse. Postcard pictures can be accurate representations, but they can also be romantic, nostalgic, optimistic, humorous, cynical, or even deceptive. Messages can convey information and emotion even in a few words, but separated from the sender and the receiver, their content is easily lost. Most of all, they are incomplete, providing fragmentary snapshots through a picture and a brief written note.

Because postcards did not gain wide distribution until the early 1900s, they do not tell the history of the settlement of the Black Hills, which was essentially over by then. Historical photographs were often reproduced in the postcard era, but they were selected to tell only the parts of history that people in 1910, or 1920, or 1930, wanted others to know. The "golden age" of postcards best captures the period from about 1905 to 1920, when cards were printed, mailed, and collected by the millions. They continued to be popular for tourists in later years, but their

personal content diminished as telephones took their place for everyday communications.

This book provides a sampling of the postcards from the Black Hills and Badlands areas from 1900 to 1960. It is impossible to know how many different postcard images were produced during that time. In addition to thousands of commercially published cards, thousands more photographs were printed with postcard backs for local families and gift shops. Many of the best items were mailed to other parts of the country, and it remains for historians or collectors to track them down. Many of the ghost towns, mines, and short-lived "attractions" may not be represented on postcards at all. I have tried to include both familiar and unusual images.

I have visited the Black Hills numerous times but I am still, basically, a tourist. The content of this book reflects that. I hope that the postcard views presented here may provide a fresh view of familiar places to long-time residents, a spark for those whose memories are fading, and a window into the past that may help us to understand the present.

I owe many thanks to the historians of the Black Hills. Without their many years of diligent work I could not have prepared the text for this book. Thanks are due the staff and collections of the South Dakota State Archives, where I did most of the research for the captions. Thanks also to my wife Wendy for her patience, support, and willingness to proofread. Finally, thanks to the many postcard collectors who encouraged me to continue with this project.

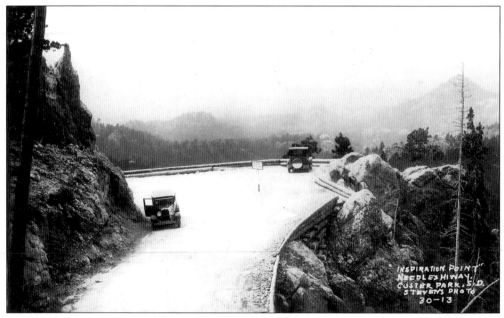

Mrs. M.I. Drennan in Norfolk, Nebraska received this postcard when her sister visited Hot Springs in September 1937, with the message, "Have been up here all week. This is a nice country."

One
WONDERS OF NATURE

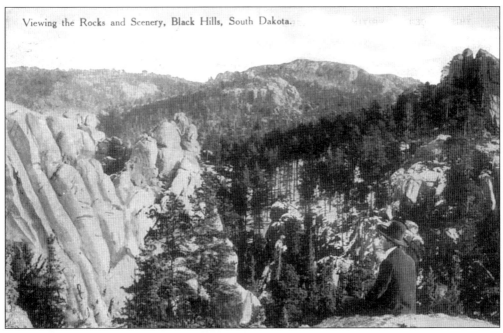

S.A. Longenecker of Rapid City published this postcard of a sightseer "viewing the rocks and scenery" of the Black Hills about 1910.

W.B. Perkins came to the Black Hills in 1879, and opened a stationery store in Lead in 1884. Later when postcards became popular he produced picture cards of Lead, Deadwood, and nearly every scenic spot in the Black Hills and Badlands.

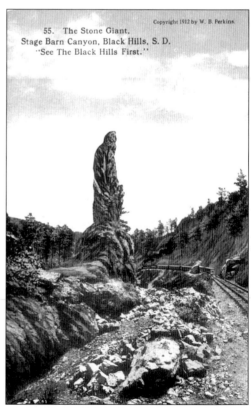

Nature created the early art work of the Black Hills, including this imitation of the perfect sculpture of the female form displayed at the Louvre in Paris.

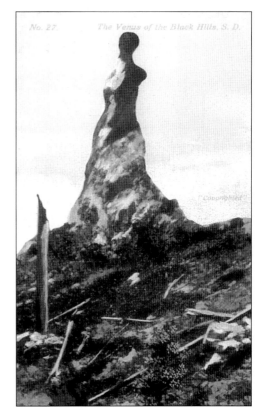

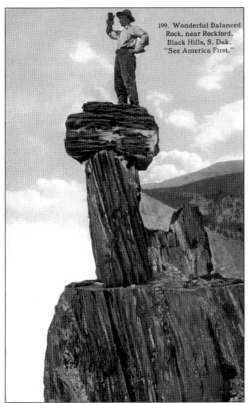

This was one of several formations named "Balanced Rock" in the Black Hills area.

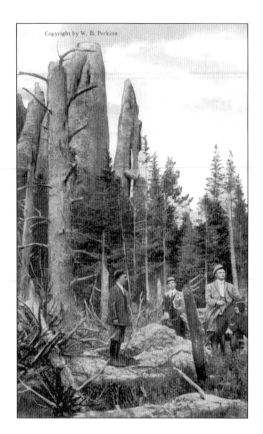

Sightseers made their way into the Needles on burros years before roads and guidebooks were available.

The sender of this postcard commented to her friend in Meriden, Connecticut, "Talk about your beauties of nature—don't you call this one?"

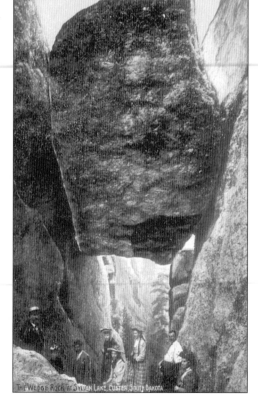

Harney Peak was a popular destination for Black Hills tourists as early as Custer's expedition in 1874.

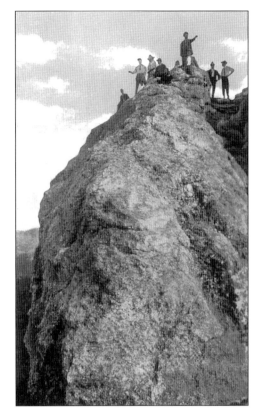

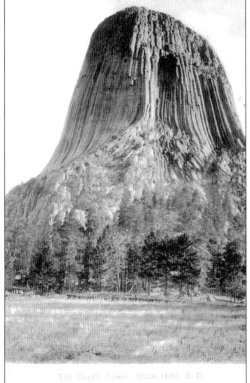

Until the beginning of World War I, many of the finest picture postcards were printed in Germany. Foreign printers sometimes placed Devil's Tower in South Dakota. Although geologically part of the Black Hills, Devil's Tower sits across the border in northeastern Wyoming.

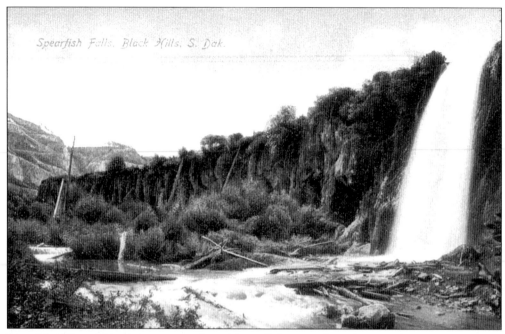

Spearfish Falls quickly became a popular subject of photographs and postcards.

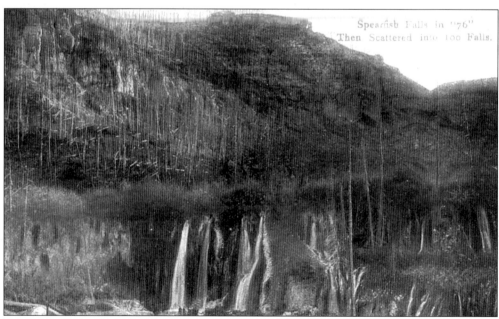

This postcard, using an early photograph of Spearfish Falls, shows water falling at several places along the escarpment.

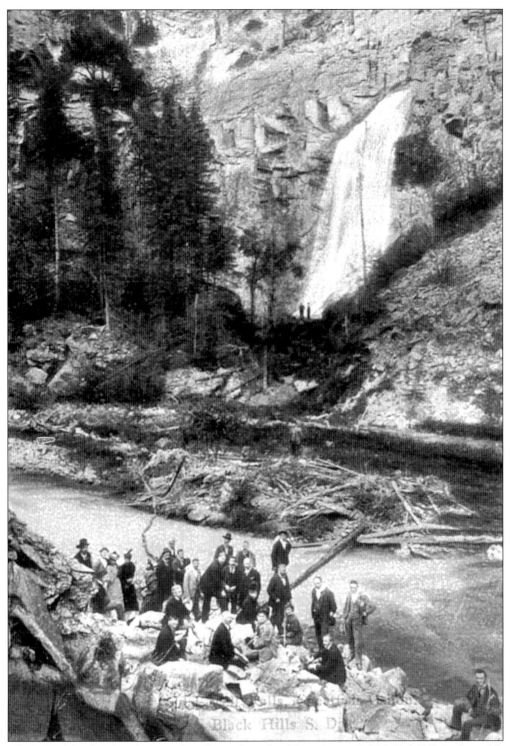
Thirty people plus the photographer showed up for this outing at Bridal Veil Falls in Spearfish Canyon.

This scenic postcard sent news in July 1910 to the school superintendent in Rockwell City, Iowa, that he had just lost a teacher to Belle Fourche: "Well I suppose you have heard I am in Dak. by now. I have just found out that I cannot take your school. Today I have contracted for a school out here so as to be near my claim, I think I have got a fine claim with good soil and a very few hills."

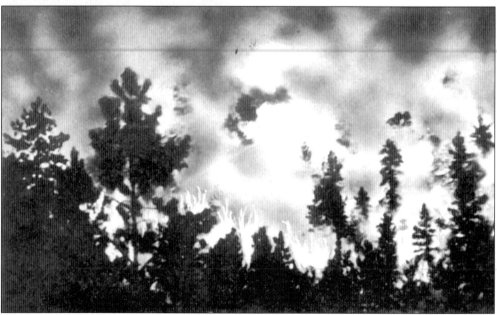

The Black Hills formed an island of forests standing above the treeless plains. Extended drought in the entire Great Plains region led to major fires in 1931, 1936, and 1939. The McVey fire in July 1939 destroyed 22,000 acres of timber, and was followed by severe flooding for the next three years.

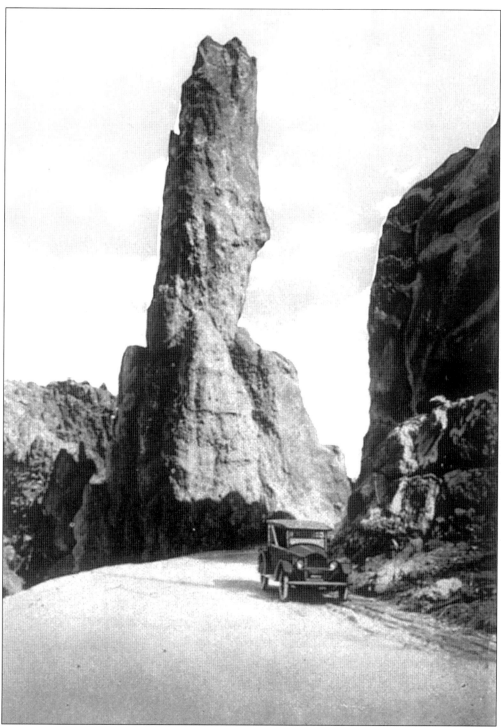

Mary Brosito wrote to her friend Miss Shipman from Spearfish in September 1927: "We had a wonderful drive through the Southern Hills yesterday with a careful driver. I enjoyed every minute. The scenery far surpasses that of northern Minnesota."

Big Foot and his band of Miniconju Sioux crossed the Badlands Wall on Christmas Eve 1890 at a point now called Big Foot Pass, attempting to evade the U.S. Army and join a group of ghost dancers on the Pine Ridge Reservation. Confrontation with the Army led to the massacre at Wounded Knee a few days later.

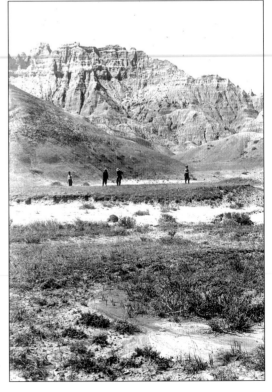

The Chicago, Milwaukee and St. Paul Railway routed their track from Chamberlain to Rapid City as close to the Badlands as possible, to provide scenic views for train passengers.

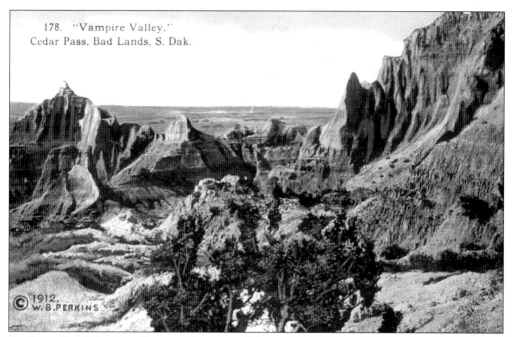

By the early 1900s, the other-worldly vistas of the Badlands had already received names such as Vampire Valley, Vulture Pinnacle, Dante's Delight, and Hell's Ten Thousand Acres.

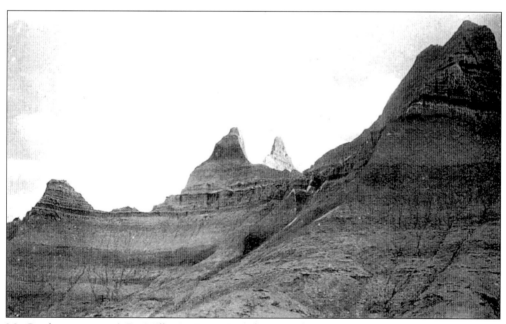

M. Cordes wrote to A.D. Miller in Front Royal, Pennsylvania: "Badlands are an immense tract of land without a sign of life or vegetation on them."

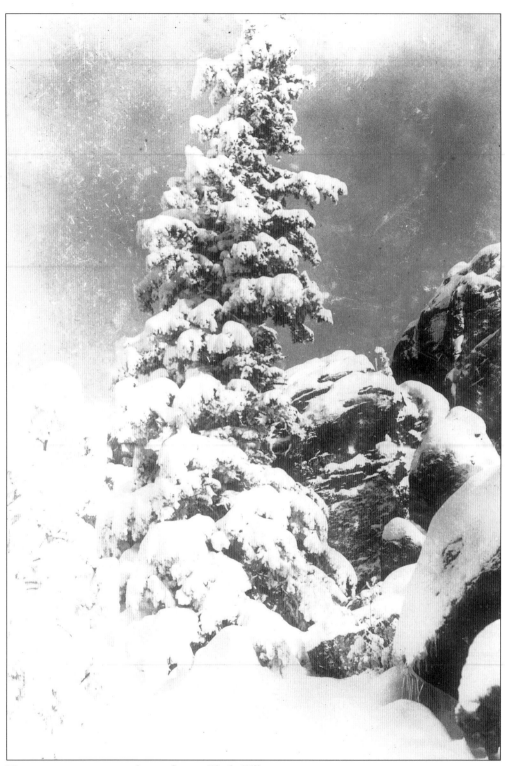
Heavy snow creates a sculpture from a Black Hills tree.

Two
GETTING THERE

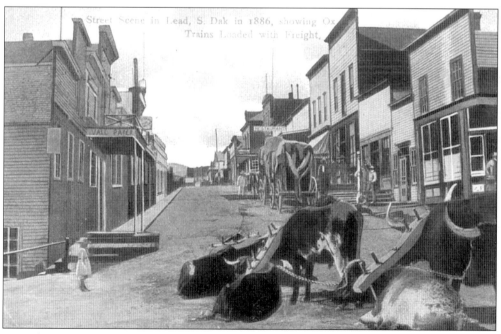

An early photograph of Lead shows ox teams leading supply wagons into town at the corner of Main and Mill about 1887. This hand-colored postcard was sent from Lead to Tate, Nebraska in 1910.

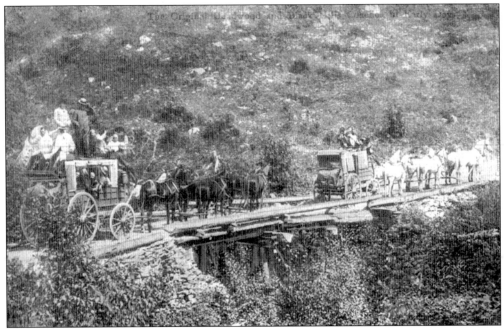

John C.H. Grabill took photographs in and around the Black Hills from 1886 to 1891. Some of his photos reappeared in later years on postcards. This Grabill photo labeled "The Deadwood Coach" was taken in 1889. The postcard was purchased and mailed twenty years later, when stagecoaches were already relics of bygone days.

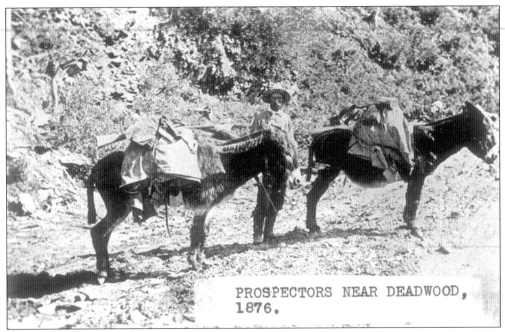

Early prospectors traveled by foot, horse, mule, and burro to explore every canyon and gulch in the Black Hills, hunting for signs of gold and other precious metals.

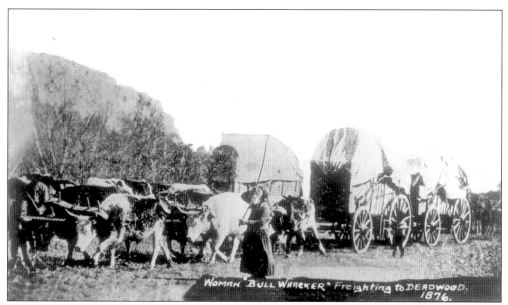

By the summer of 1876, thousands of gold prospectors and other fortune hunters had gathered in camps throughout the Black Hills. Supplies of food, clothing, tools, and building materials were badly needed. Strings of wagons pulled by ox teams carried tons of supplies from steamboat landings at Yankton and Fort Pierre, and railheads in Nebraska, to the camps in and around Deadwood.

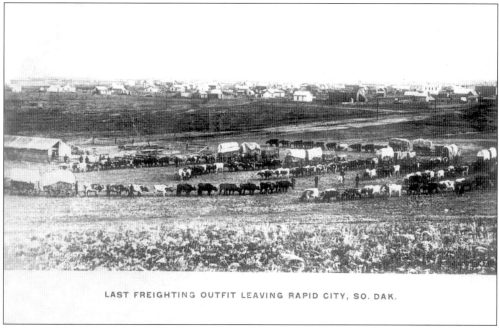

Rapid City was a perfect place for ox teams to rest before starting the climb into the Black Hills. This photograph by J.F. Baker shows the French Brothers Barn and the Northwest Transportation Company bull train in the Gap at the foot of Hangman's Hill, looking east toward Rapid City. Railroads quickly replaced the ox and wagon trains after the Fremont, Elkhorn, and Missouri Valley Railroad arrived in Rapid City in 1886.

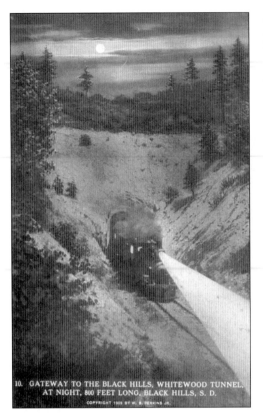

The Fremont, Elkhorn, and Missouri Valley Railroad completed track from Rapid City to Whitewood in 1887, and on December 29, 1890, this tunnel allowed the "first passenger train from the outside world" to enter the town of Deadwood.

Engineers laid track in a large horseshoe bend around the 500-foot-high Knife Blade Rock in Elk Creek Canyon.

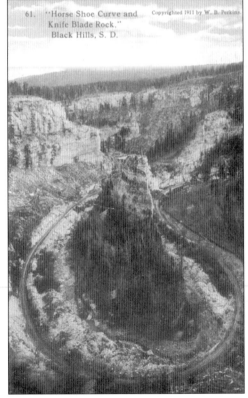

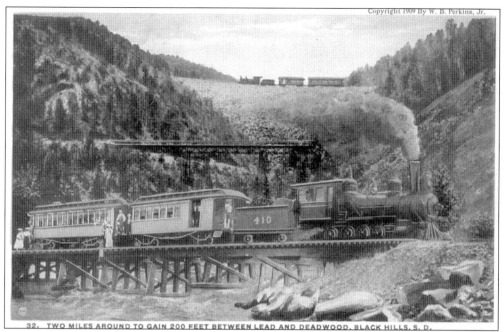

Railroads not only linked the Black Hills to the outside world, but also provided important connections between towns in the canyons where wagon roads were treacherous and frequently impassable. Called the "Slim Princess" by promoters and the "Little Dinky" by others, this narrow gauge train at one time provided hourly service between Lead and Deadwood.

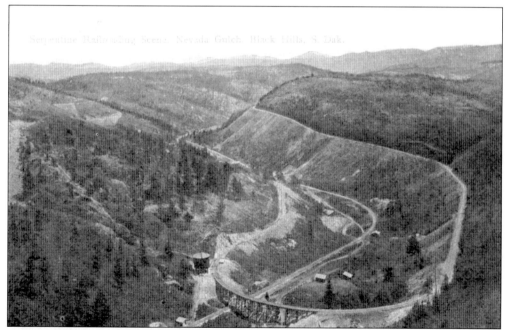

This picture shows the town site of Terry, near the trestle. The narrow-gauge Fremont, Elkhorn, and Missouri Valley line crossed a high trestle at Terry to gain altitude, while the Deadwood Central tracks ran along the bottom of the canyon.

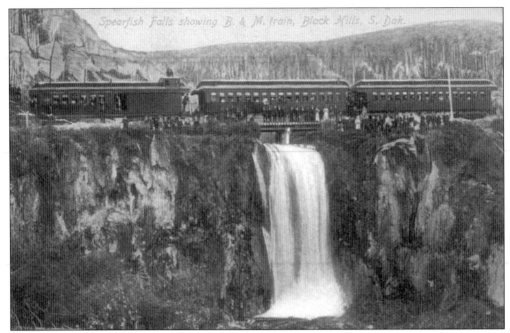

Spearfish Falls was a major scenic attraction, and a regular train stop, until most of the water was diverted to the Homestake hydroelectric plant near Maurice.

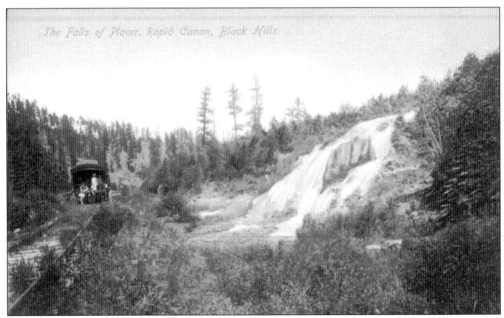

Early Black Hills trains often stopped on the tracks to accommodate sightseers, picnickers, berry pickers, and fishing parties.

With the completion of an iron bridge crossing the Missouri River at Pierre, and the last part of the line between Fort Pierre and Rapid City, the Chicago and North Western Railroad completed the first railroad connecting the eastern and western halves of South Dakota in 1907. The Chicago, Milwaukee and St. Paul Railway finished a parallel line between Mitchell and Rapid City a few months later.

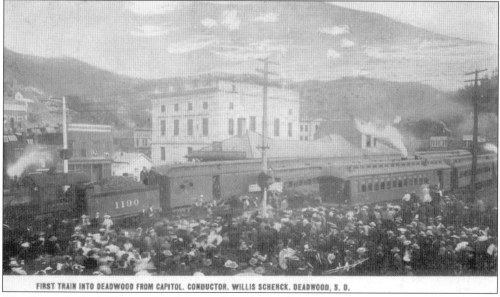

The first train from Pierre arrived in Deadwood on July 14, 1907, four days after a connecting spike was driven in Philip to complete the Chicago and North Western line across the state. Until this time travelers from Sioux Falls, Mitchell, or Huron had to travel through Nebraska to reach the Black Hills by train.

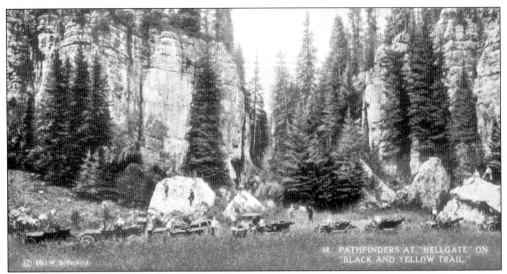

In 1913, the "Pathfinders" traveled from Chicago to Yellowstone Park to blaze a trail for automobile tourists, one of several routes created by local promoters and private citizens before state and federal governments developed highway systems. Striped posts marked the "Black and Yellow Trail" until it became U.S. Highway 14. The sender of this card advised a friend, "You & Ben ought to take that Black & Yellow Trail, it runs through Pierre & Ft. Pierre—Lots of tourists go through every day."

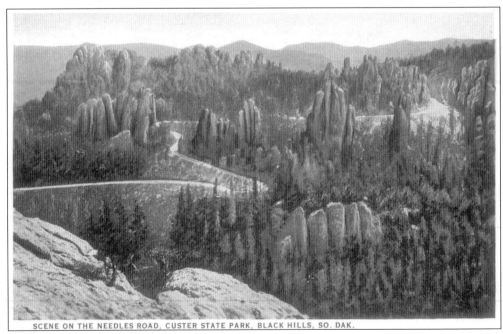

Scovel Johnson engineered many of the highways, trails, and campsites in Custer State Park. The Needles Highway, Sheep Mountain Road, and Iron Mountain Road were all constructed specifically to move tourists in and out of the most scenic areas. In Johnson's words, the new roads made the "miniature kingdom of perpendicular cliffs and canyoned waterfalls" accessible to the "inexpensive but arrogant tin Lizzie."

As automobiles became increasingly popular, the town of Deadwood found it necessary to improve several hazardous access roads, before state funds were available. The Boulder Canyon Road connected Deadwood with Sturgis.

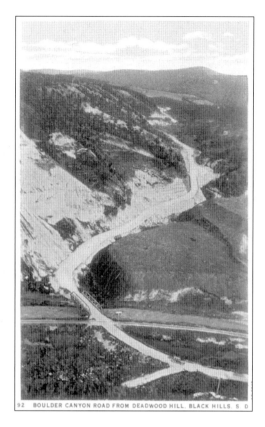

BOULDER CANYON ROAD FROM DEADWOOD HILL, BLACK HILLS, S.D.

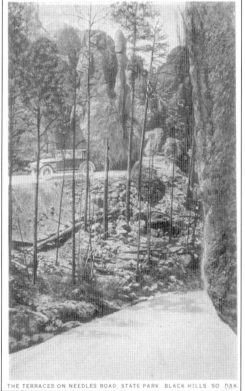

THE TERRACES ON NEEDLES ROAD, STATE PARK, BLACK HILLS, SO. DAK.

Parts of the Needles Highway were still under construction when R.A.W. posted this note to a friend back home in New York City in 1926: "Am spending four weeks in S.D., Nebraska & Colorado. Lead where I am today has the largest gold mine in U.S. It's a very different world from N.Y."

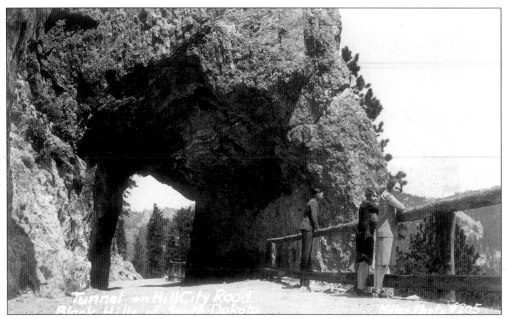

Roads were needed to make the scenic attractions of the Black Hills accessible to automobile traffic. At the same time, engineers built tunnels, bridges, and winding curves in order to make the roads themselves attractive, and to slow the cars down so that people would take more time to enjoy the scenery.

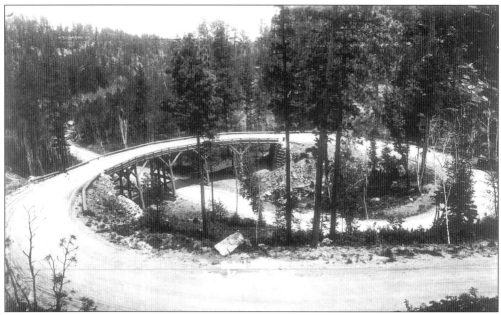

"Pigtail" spiral bridges were built on the roads leading to the new Mount Rushmore Memorial, which began construction in 1927. A visitor wrote to her friend in Rockwell City, Iowa, "I wouldn't want to ride with you on this road if you'd had a hot chocolate. Ha! We went over several of these today. Having a swell time."

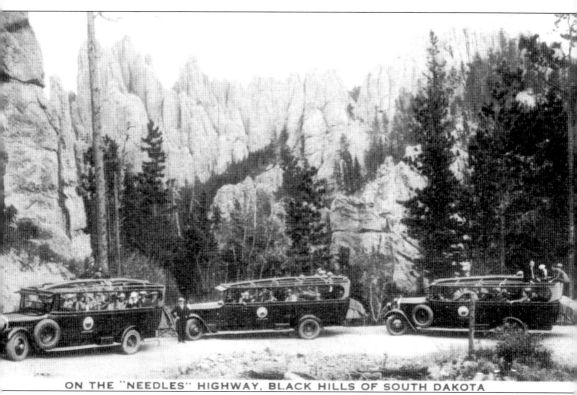
ON THE "NEEDLES" HIGHWAY, BLACK HILLS OF SOUTH DAKOTA

The Burlington Route published this postcard to advertise the Black Hills "detour," which allowed train passengers to take a few days to tour the area by bus or auto before continuing their journey to Yellowstone National Park and other western destinations.

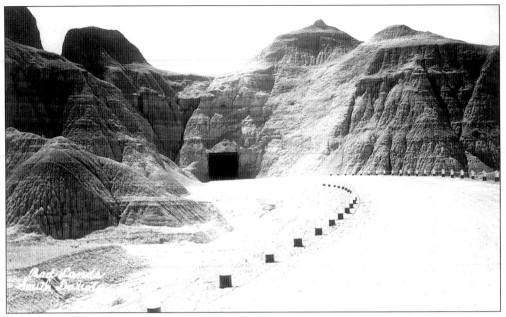

As governor and later U.S. Senator from South Dakota, Peter Norbeck worked for many years to create a national park in the Badlands. He wanted roads to pass through the most scenic, and therefore the most difficult parts of the terrain, where building roads created engineering nightmares. The Badlands received National Monument status in 1939, and became a National Park in 1978.

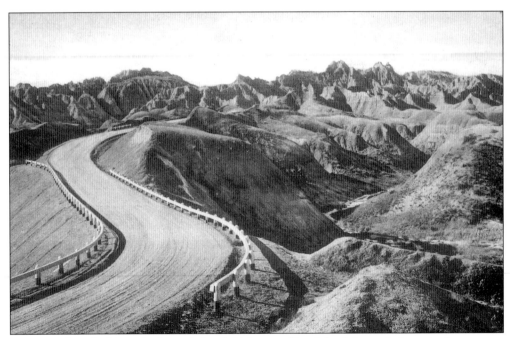

A woman described her trip through South Dakota to friends back home in Iowa in the summer of 1941: "Went through the Badlands Sun. afternoon. I have never seen anything so wonderful in all my life. It doesn't seem possible this sort of thing is on the same hemisphere as Des Moines."

> Interior, S. Dak., _____ 192__
>
> We are at Interior, S. D., in Wonderland Park. This is in the Heart of the Bad Lands. We took Highway No. 40 or Rain-Bo Trail from Chamberlain to Rapid City. This Highway is south of the C. B. H. and leaves the C. B. H. at Kadoka. This is the only route to the Black Hills on which you see the Bad Lands and is the shortest route. There is no Bad
>
> Land scenery on the C. B. H. The roads are _____; little towns every 12 miles. Interior has some of the best water in the state. From here we can see the best sight in the Bad Lands, which is "Cedar Pass." We are stopping at "Tourist Inn," which is a clean, modern stopping place with all accommodations for tourists. Be sure and take Highway No. 40 to see the Bad Lands. Free Tourist Park.

This postcard encouraged tourists to follow the Rain-Bo Trail instead of the better-known Custer Battlefield Highway ("C.B.H."), in order to see the Badlands where tour roads were starting to be developed, and of course to stay overnight in Interior at the Tourist Inn.

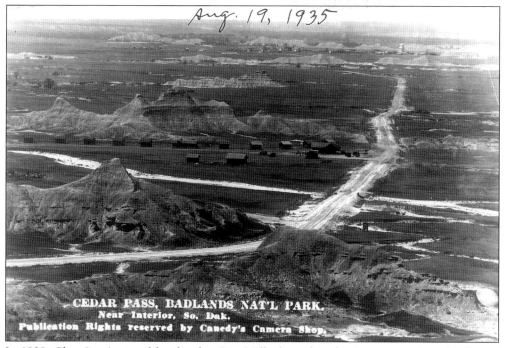

In 1928, Clara Jennings and her brother Ben Millard purchased private property at the foot of Cedar Pass for a campground and resort. Millard built cabins and a dance hall from inexpensive bark-covered slabs trucked in from Black Hills lumber mills. The town of Interior with its grain elevator can be seen in the distance.

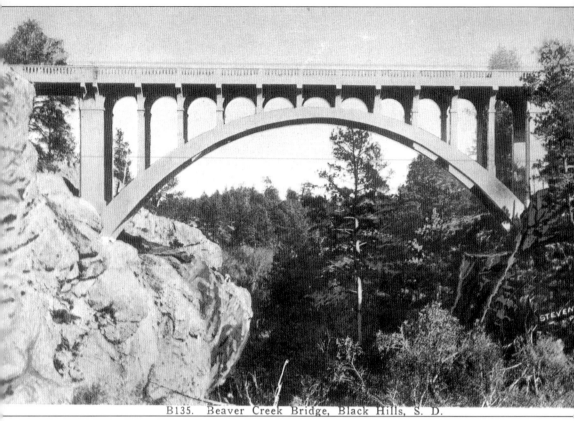

B135. Beaver Creek Bridge, Black Hills, S. D.

The printed caption on this postcard praised the Beaver Creek Bridge on Highway 87 as "only one of the many picturesque and substantial bridges greeting the traveler as he drives or hikes along the scenic routes in the Black Hills of South Dakota." An actual traveler mailing the card to a friend in Slater, Missouri in 1938 added, "Beautiful place but takes nerves to make some drives."

Three
MINING

In 1874, Lieutenant Colonel George A. Custer led an expedition of 1,000 men, 110 wagons, and over 2,000 horses, mules, and beef cattle into the Black Hills to survey a location for a military post. Expedition photographer William H. Illingworth produced commercial "stereopticon" photos of the trip, and these images were among the first the American public saw of the Black Hills. *(Photo courtesy of the SD State Historical Society—State Archives)*

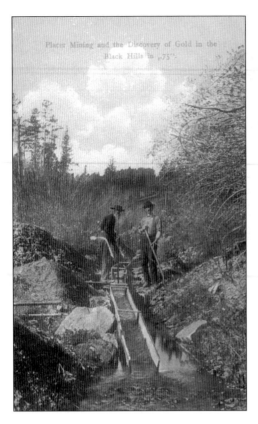

Early prospectors set up placer boxes to separate gold dust from the gravel in streambeds, and they soon fanned out through every canyon and gulch in the Black Hills area.

Dairy operator Otto P. Grantz located the Hidden Fortune mine near Lead in 1886. The fortune remained hidden until 1889, when Grantz finally found a rich gold vein. The Hidden Fortune, along with many other mines and mills in the Lead-Deadwood area, was eventually acquired by the Homestake Mining Company.

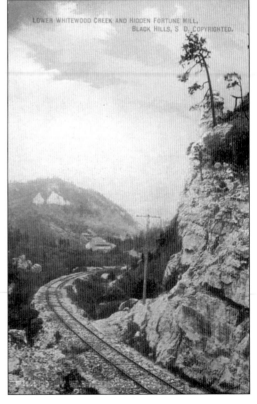

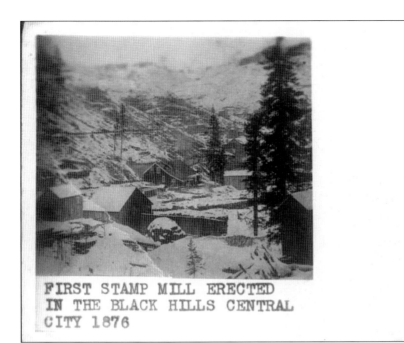

FIRST STAMP MILL ERECTED IN THE BLACK HILLS CENTRAL CITY 1876

Placer mining along streams was quickly replaced by tunneling into the hard rock to find veins of gold and silver in quartz and other minerals. Ox teams brought heavy metal equipment from the closest railhead in Nebraska for stamp mills to crush the ore so that the gold could be extracted.

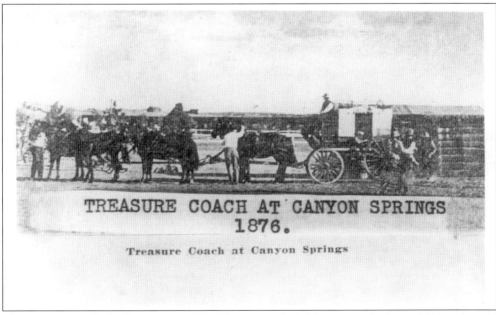

TREASURE COACH AT CANYON SPRINGS 1876.

Treasure Coach at Canyon Springs

This coach specially built to carry gold bullion was only held up once. In 1878, $40,000 in gold bricks was stolen in a bloody raid that left several passengers and robbers dead or wounded. According to one story, the gold bricks were recovered after being displayed in a bank window in Atlantic, Iowa by the naïve father of one of the robbers.

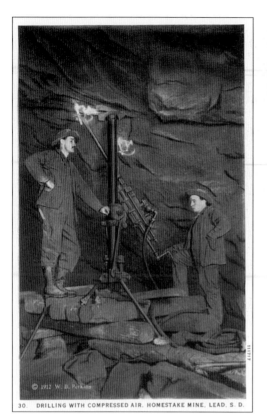

Homestake purchased a new air-powered drilling machine in 1912. The miners in this picture still wore soft hats and used candles for light. Each miner received three candles per shift.

The extensive underground tunnels of Homestake required massive timbers for support. Homestake had its own lumber mills and railroads to bring the wood to Lead.

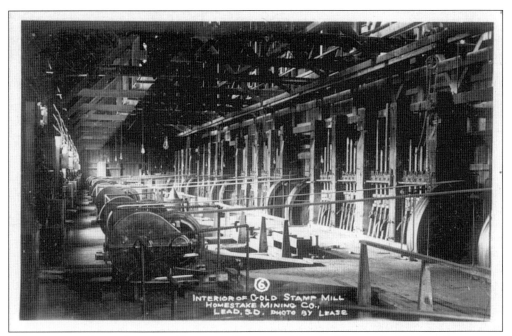

This was one of several stamp mills eventually operated by the Homestake Mining Company.

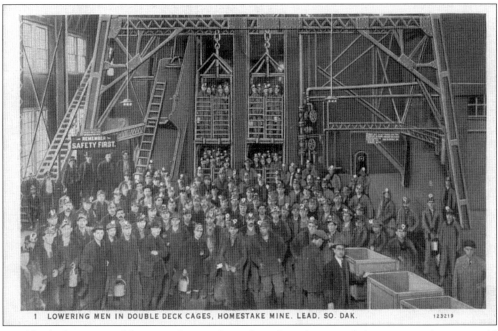

Double-deck cages could put two layers of men into the mine tunnels in one operation, or could lift two ore cars coming from the depths.

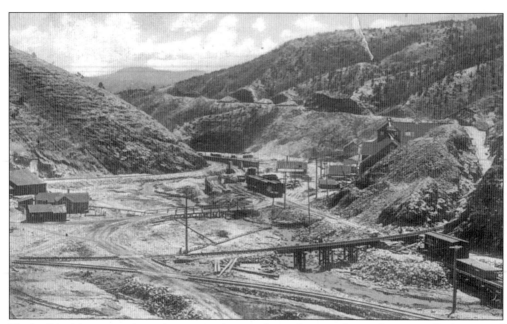

Blacktail had its own train station at one time, and was the site of several stamp mills that served nearby mines including Cook's Mill, Baltimore & Deadwood, Gustin, Esmeralda, Minerva, and Hildebrand.

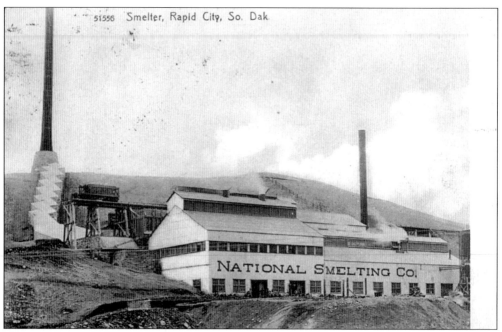

This smelter with a 140-foot smokestack, built in Rapid City in 1902, extracted gold from types of ore that could not be processed in the regular stamp mills.

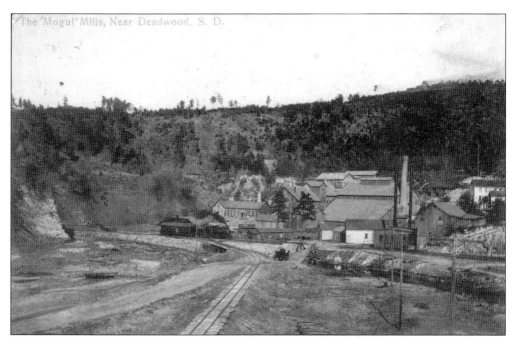

In the 1890s, Homestake, Portland, Mogul, and Golden Reward all had prosperous mining operations. By the time this postcard was sent in 1917, the Mogul mine had shut down due to lack of materials and high prices.

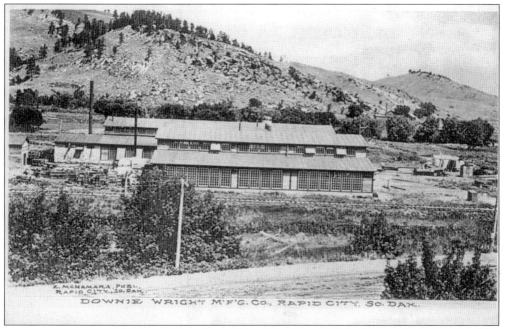

The Downie Wright Manufacturing Company from York, Nebraska opened a factory in Rapid City to build pulleys, shafting clutches, and other mining machinery. Merchants in Deadwood and Lead were so concerned about competition from Rapid City that they refused to buy products from Downie Wright, and put the factory out of business within a few years.

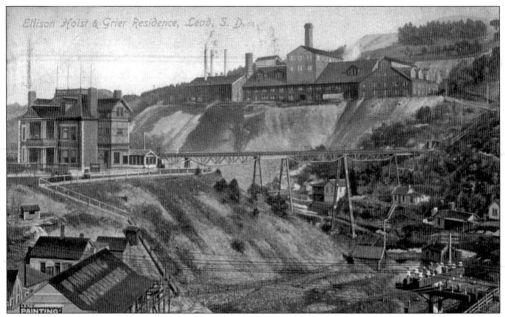

T.J. Grier, superintendent of Homestake's operations in Lead from 1884 to 1914, took over the old mine offices and remodeled them into a beautiful home for his new wife, Mary Jane Palethorpe, the first Lead librarian, who moved into the residence in 1896.

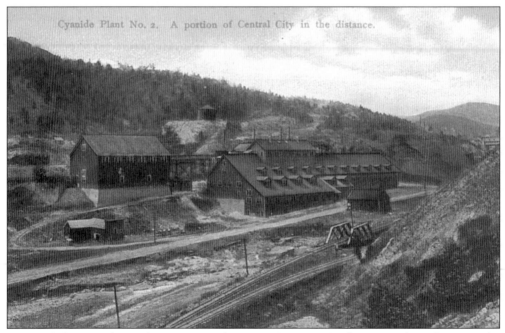

Homestake's Cyanide Sand Treatment Plant No. 2 near Gayville operated until 1934. The building served for a time as an ice skating rink sponsored by the American Legion, and in 1965 was demolished.

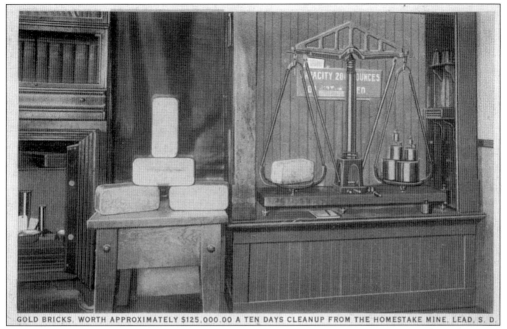

GOLD BRICKS, WORTH APPROXIMATELY $125,000.00 A TEN DAYS CLEANUP FROM THE HOMESTAKE MINE, LEAD, S. D.

According to Estelline Bennett in her book *Old Deadwood Days*, officials at the Homestake assay office offered to give a gold brick to anyone who could lift it, "but I lifted one a fraction of an inch and they did not give it to me."

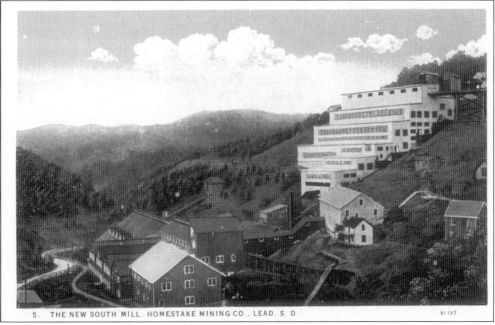

5. THE NEW SOUTH MILL, HOMESTAKE MINING CO., LEAD, S. D.

The South Mill, completed in 1926, contained 1020 stamps and six rod mills for crushing ore into fine powder. Rod and ball mills replaced the stamps when the facility was remodeled in 1952-1953.

43

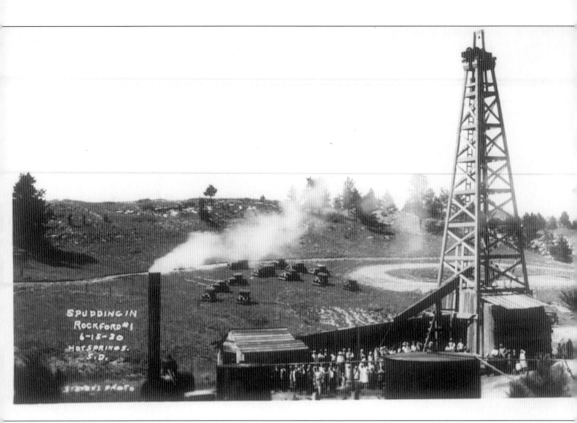

Rockford #1 was the second well of the Black Hills Petroleum Company to bring up oil. The new oil wells brought much excitement to the Hot Springs area in the summer of 1930, although South Dakota wells never produced as much crude as the fields in the neighboring states of Wyoming, Montana, and North Dakota.

Four
BUILDING COMMUNITIES

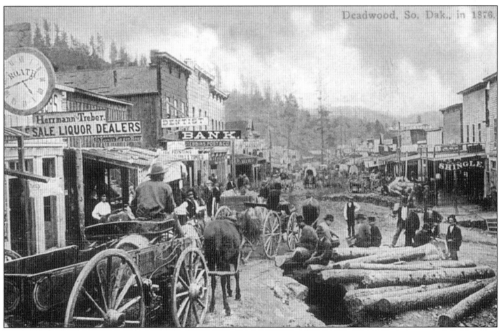

One of the best-known photos of gold-rush Deadwood appeared over and over on postcards and in books. Deadwood itself quickly left its frontier beginnings behind. Devastated by fire in 1879 and by flood in 1883, the downtown area was soon rebuilt into a modern city with sturdy fireproof brick buildings.

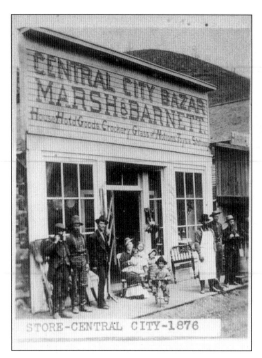

Collins' History and Directory of the Black Hills, published in 1878, said that F.G. Marsh and Henry Barnett had "the largest establishment in its line in the Hills, outside of Deadwood." The store carried a full line of household furnishings, including "furniture, glass and queensware, pictures and frames, stationery, notions, tobacco, cigars, pipes, etc."

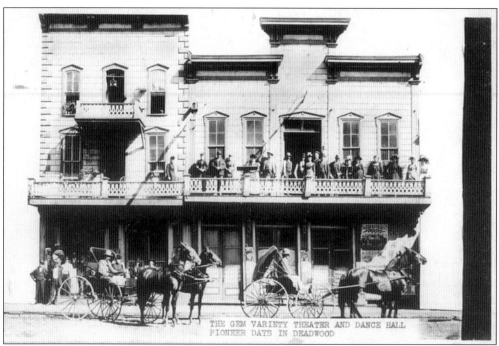

The Gem Theater in Deadwood was one of the best known and longest-lived of the mining camp theaters. Al Swearengen, the manager and proprietor, sits in the carriage at left with his wife, and Johnny Burns, the "box-herder" who worked the curtained boxes along the sides of the main show where the real entertainment began, is in the carriage at right. The building burned down in 1902.

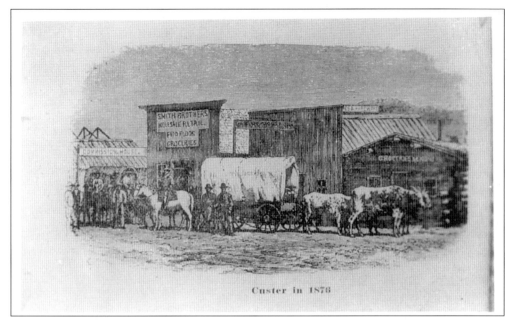

This unattributed engraving of "Custer in 1876" probably appeared first in an eastern magazine. It may have been drawn from a photograph, or it may have been completely fabricated by an artist to accompany a story on the gold rush. The postcard is a photographic reproduction made many years later, probably in the 1920s.

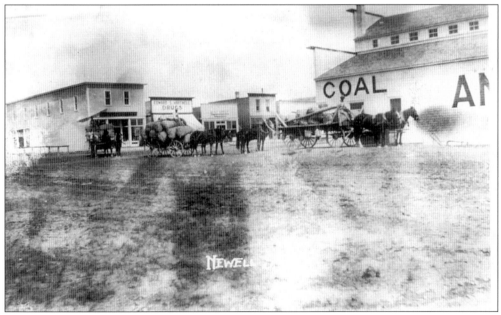

The town of Newell was founded long after the area was homesteaded, after the Belle Fourche Irrigation Project attracted many new people and businesses to Butte County. This picture of Main Street shows a grocery store, drug store, and restaurant, along with the J.F. Anderson Lumber Company at right, one of the first businesses to set up in Newell in 1910 before the town site officially opened.

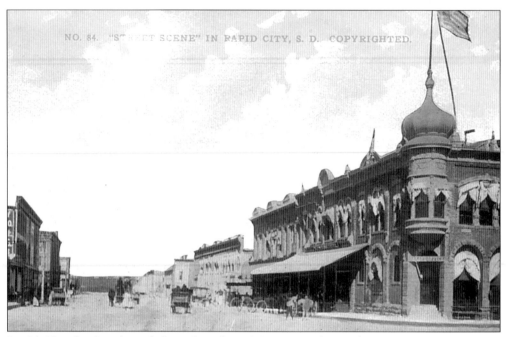

Rapid City developed much later than the mining towns, but its location as a transportation center for the entire Black Hills led to steady growth.

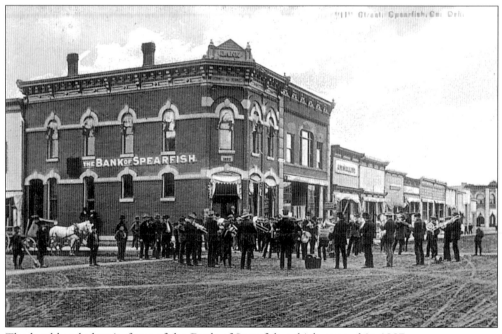

The local band plays in front of the Bank of Spearfish, which opened in 1887.

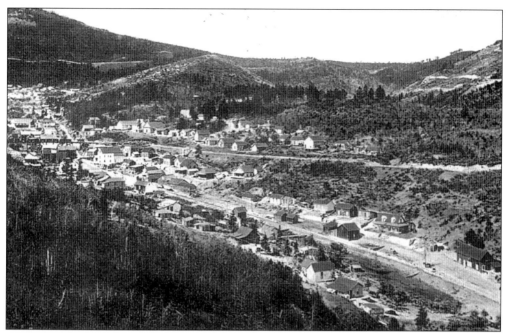

The town of Terry had 1,177 residents in 1910, the year this postcard was mailed to Topeka, Kansas. Terry was the home of the Golden Reward and Horseshoe mines.

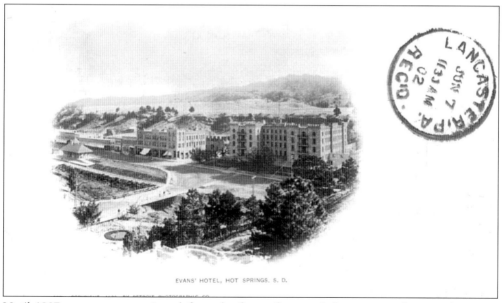

Until 1907, space was sometimes left on the front of postcards for messages, because they were not allowed on the address side. This early view of downtown Hot Springs was sent to "Miss Eshleman" in Lancaster, Pennsylvania, without any return address or message. Hopefully she recognized the handwriting. The picture shows the Minnekahta Block and Evans Hotel, built by entrepreneur Fred T. Evans in 1891 and 1892.

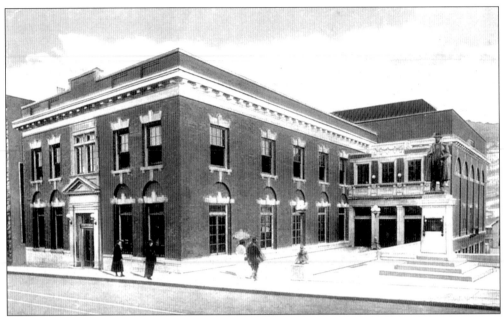

T.J. Grier, long-time superintendent of Homestake, built the Recreation Building as a legacy to the community of Lead, and lived just long enough to see it dedicated in 1914. The building included a billiard room, swimming pool, bowling alley, a permanent room for the Hearst Free Library, lounge, clubrooms, and a theater with a stage for live performances and a screen for silent movies.

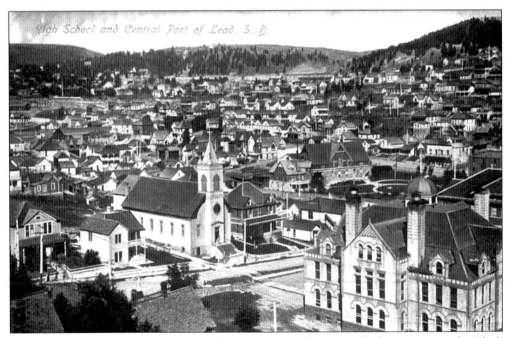

Lead turned into a settled community of 6,210 residents by 1900, the largest city in the Black Hills. The high school building at the lower right was completed in 1896, and the Assembly Hall behind it was added in 1903. St. Patrick's Catholic Church, at lower left, was constructed in 1902.

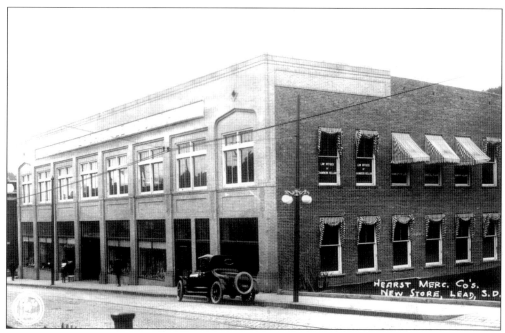

The Hearst Mercantile store opened in a new building in 1922 just west of the Recreation Building. It also housed the general offices of the Homestake Mining Company.

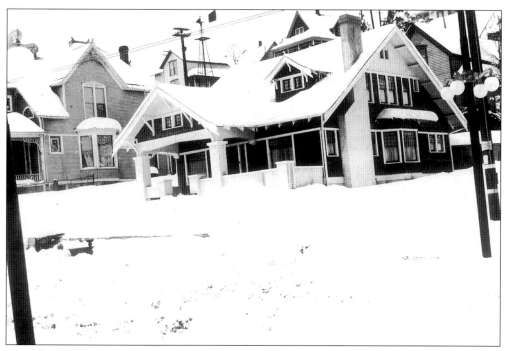

New films, cheaper cameras, and photographic paper preprinted with postcard backs made it possible to send snapshots to friends within a few days. This one was mailed three days after it was taken in Lead in 1916 with the message: "This is a picture I took on the 15th of May, we are still having winter evidently. What do you think of this for good Kodak work."

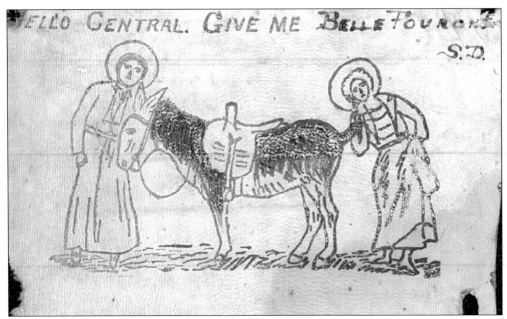

Novelty postcards made from real leather could be mailed, and this one poked fun at another new communications device, the telephone.

The sender chose this card to send a message to a friend in Hoover, S.D. about his new job in Black Hawk at the Dakota Plaster Company in 1910: "I am working every day on a new stucco mill."

Many stock postcard images were produced with space to overprint the name of a local town. This scene was part of a "Local Comics" series of 25 designs.

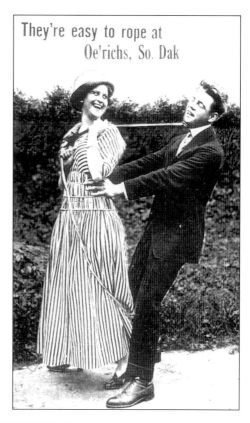

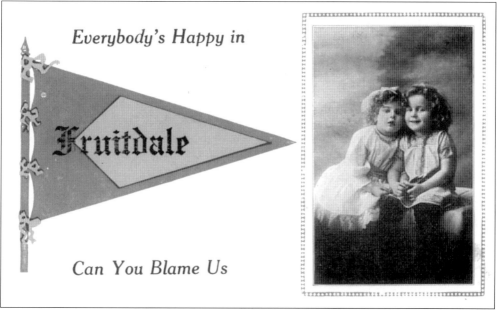

Fruitdale was platted in 1911 along the new railroad through the Belle Fourche Irrigation Project area. This postcard sent Christmas greetings from Josephine in Arpan, another nearby town, to her friends Clara and Emma Jensen in Renner, on the other side of the state.

Trout are not native to the Black Hills area, and introducing trout into local streams and lakes was considered an important step towards civilization and development. DeWitt Clinton Booth brought 100,000 trout eggs with him to start a federal trout hatchery in Spearfish in 1899. The hatchery operated until 1983, when it was turned into a historic site and museum.

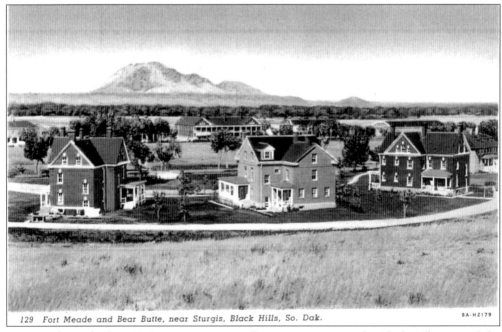

129 Fort Meade and Bear Butte, near Sturgis, Black Hills, So. Dak.

Fort Meade was built in 1878 as a permanent military post to protect the Black Hills area and the town of Sturgis grew up nearby to provide services for the soldiers.

Hans Amunson, a Norwegian immigrant, moved with his family to the new town of Newell in 1910. His wife Matilda used this postcard showing their house to write to her daughter Fara in Woonsocket in the winter of 1917: "im sending you a pakig to Day your Dreas and overshoe so you will get it when this card get there, and I will send your muff and som other tings."

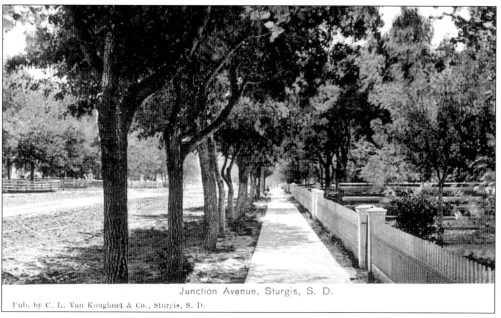

A tree-lined avenue with sidewalks, picket fences, and deep setbacks portrayed Sturgis as a peaceful and well-developed town in 1910.

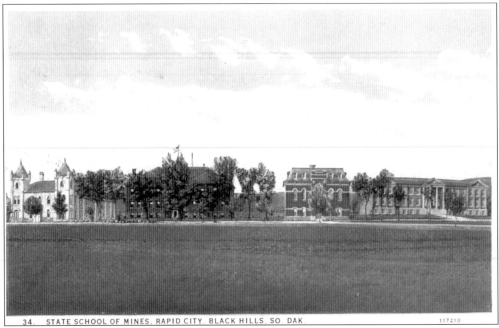

Instruction at the State School of Mines in Rapid City began in 1886.

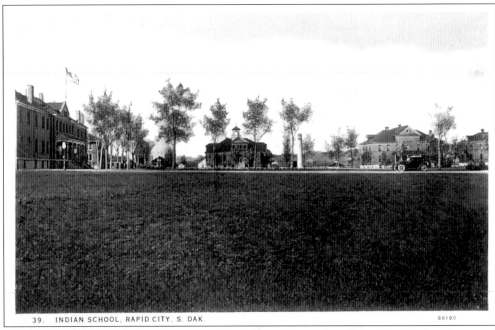

The Rapid City Indian School was one of 25 off-reservation boarding schools when it opened in 1898. In 1913, the school had 160 boys and 130 girls in attendance, mainly from the Pine Ridge, Cheyenne River, and Rosebud reservations, but also from Montana and Wyoming. The original building, in the center of the picture, burned down in 1923. Students cultivated 400 acres of land attached to the campus.

This postcard shows the College Hall, Training School, and Gym of Spearfish Normal School, which later became Black Hills State University.

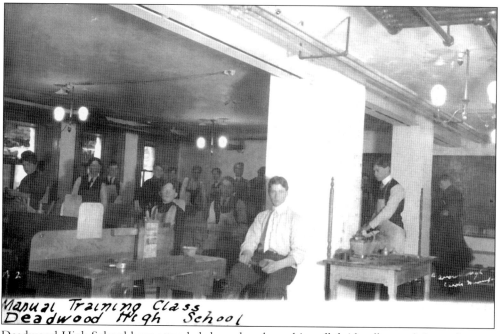
Deadwood High School boys attended shop class dressed in celluloid collars and ties, at least on the day this photograph was taken.

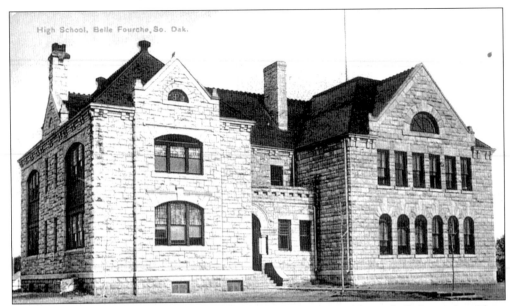

A new building for the Belle Fourche school opened in 1903 and housed all the grades. Three girls formed the first graduating high school class in 1905. By 1907, a south wing was added to accommodate the student body that had grown to 250.

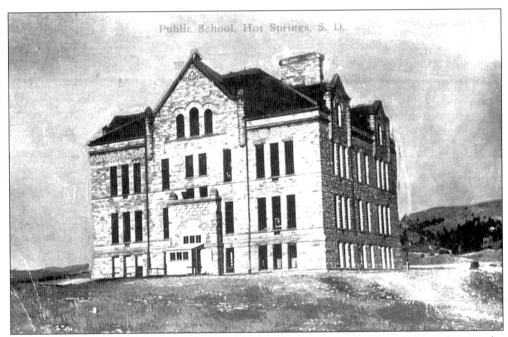

A new stone school building opened in Hot Springs in 1893. The first floor held grades 1-4, the second floor grades 5-8 and the high school, and the third floor served as a gymnasium. The high school moved to new quarters in 1910, and when the grade school received new facilities in 1961, local residents formed the Fall River County Historical Society to take over the building as a museum.

The Dakota territorial legislature created Custer, Lawrence, and Pennington counties in the Black Hills in 1877. A permanent courthouse was completed in Custer in 1881.

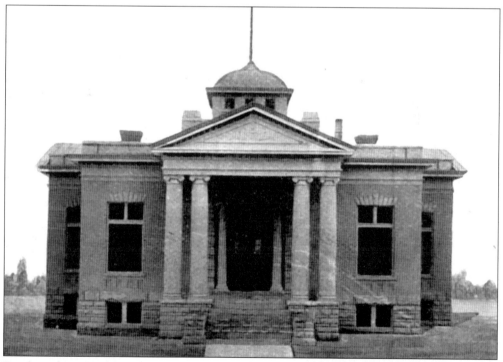

Deadwood received $15,000 in 1902 from steel magnate Andrew Carnegie to build a public library, which opened in 1905. Carnegie libraries were also built in Hot Springs in 1907 and Rapid City in 1914.

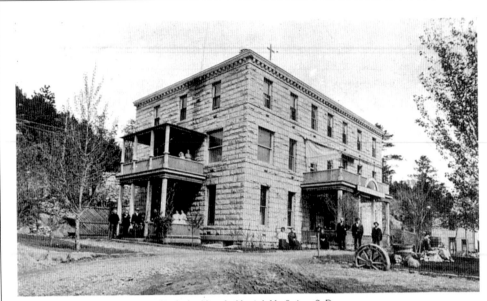

Our Lady of Lourdes Hospital, Hot Springs, S. D.

The Benedictine Sisters of St. Martin's Convent opened a state-of-the-art hospital in Hot Springs in 1901, which included "deadened floors, electric bells, furnace heat, star ventilator system, luxfer prism lights, wide halls and stairways, complete operative and medical departments, and all the improvements which go to make up a twentieth century hospital."

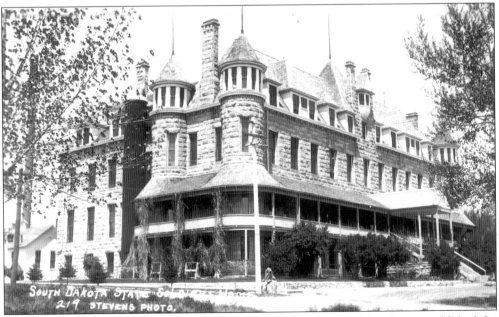

As one of its last acts before statehood in 1889, the Dakota territorial legislature established the State Soldiers Home in Hot Springs.

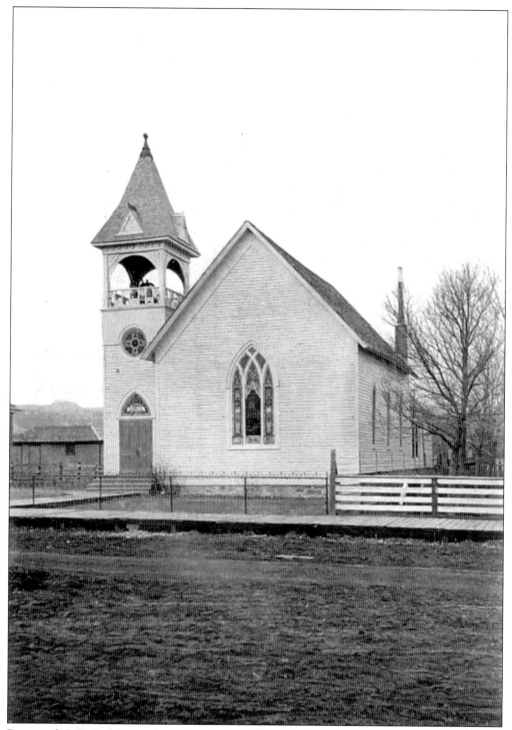
Reverend C.D. Erskine used a postcard view of his church in Sturgis to invite an acquaintance to services.

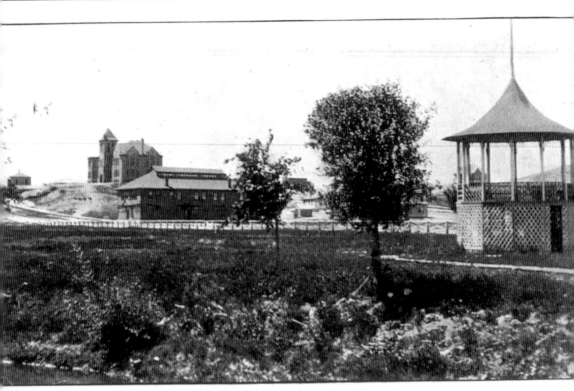

PARK SCENE, EDGEMONT, S. D.

Edgemont developed early as a railroad depot, and served a large ranching area on the South Dakota Wyoming border. The city park along the railroad tracks was spruced up in 1903 for the visit of President Theodore Roosevelt. Edgemont High School stands on the hill in the distance.

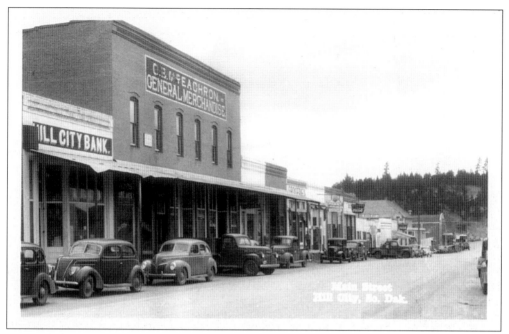

Hill City was the second town founded in the Black Hills in 1876, but it was soon abandoned as miners moved to new gold strikes further north. A tin boom in the 1880s brought people back, and the town prospered in later years with help from the lumber and tourist industries.

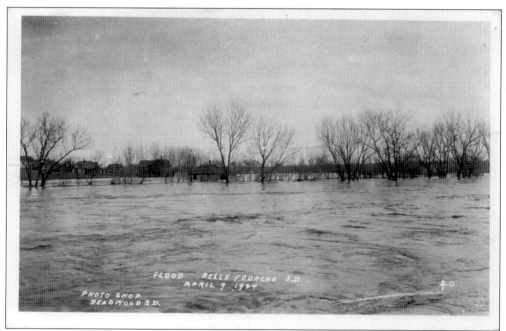

Three months after a devastating flood damaged homes and farms in Belle Fourche in 1924, visitors reported to friends in Ellingson, S.D. that "this river is beautiful."

Children pose in their yard for a picture by local photographer O.A. Vik in Sturgis. St. Martin's Academy, a Catholic school started by the Benedictine Sisters in 1889, can be seen in the background.

Five

FARMING AND RANCHING

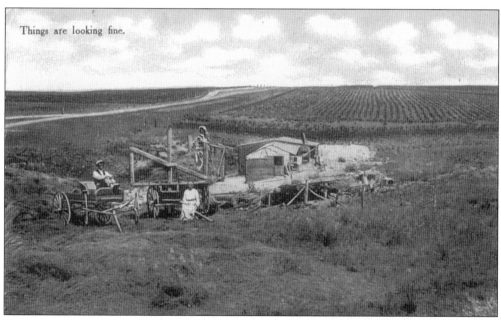

A good sense of humor was essential to the survival of homesteaders who braved difficult conditions and isolation on the Dakota prairies. S.A. Longenecker published an extensive series of postcards showing claim shacks and their owners. Many of the cards were used by homesteaders and farm workers to send messages to the family members and friends they left behind.

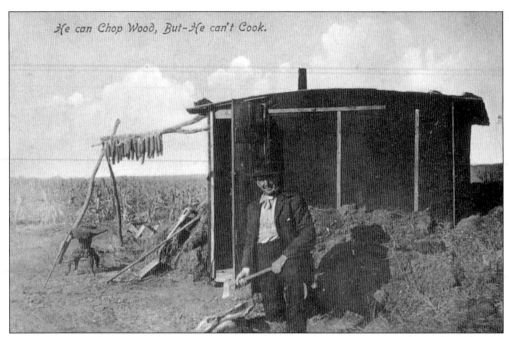

Early settlers made the best of their situations. Many homesteaders lived in tarpaper shacks for the minimum required number of days in order to obtain title to the land, not intending to farm but only to resell as soon as possible.

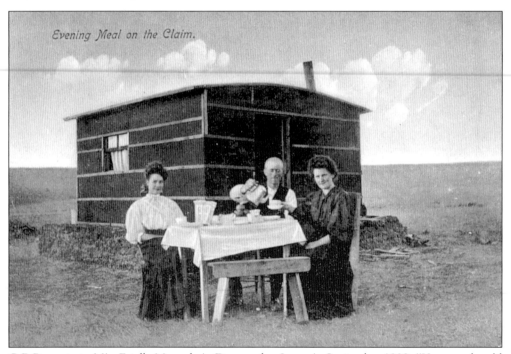

G.B.P. wrote to Miss Estelle Messerly in Duncombe, Iowa, in September 1909, "Your card rec'd how are you? I am fine and dandy. We are going to thrash soon, but my wife won't cook for them."

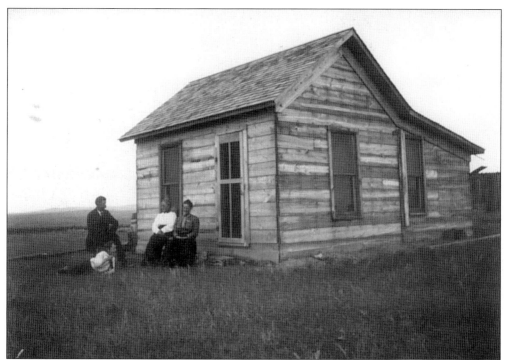

O.A. Vik immigrated to America from Norway as a young man and worked on a relative's farm near Elk Point until he saved enough money to buy his first camera. He opened a photo studio in Sturgis in 1908, and published many photographs and postcards including this unidentified farmhouse.

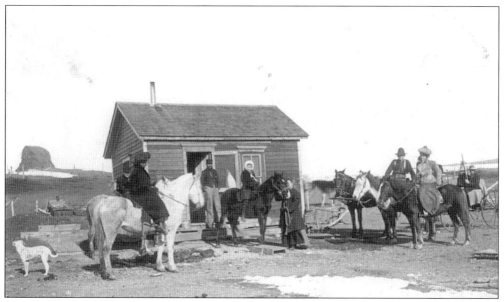

Wayne White wrote from Cottonwood on June 13, 1908 to Clara Jobe in Humboldt: "This girl on the white horse is your twin sister. She is the prettiest girl out here, least I think so. (I seen Mary Zapp about two weeks ago she is a bird in the gilted cage.)"

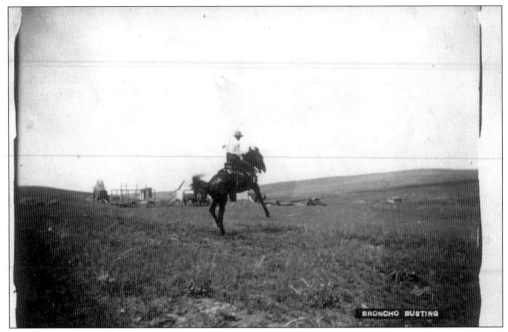

"H.B.F." purchased this postcard produced by Philip photographer Gustav M. Johnson and mailed it from Zeal, on the eastern edge of Meade County, to his father in Manchester, Iowa in September 1910 with news of a new job: "Will start Friday morning. Good bye."

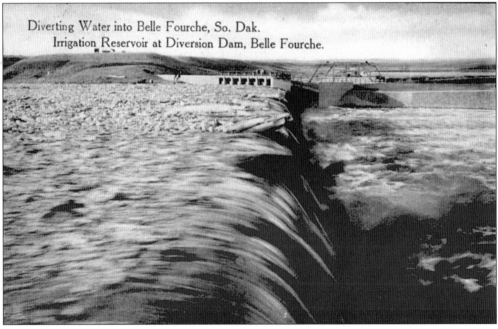

The Orman Dam provided irrigation water for a large area north of the Black Hills. The company that started the project used 250 teams of horses at a time to move soil and rock for what was at the time the largest earthen dam in the world. Cucumbers, sugar beets, and peanuts were tried on the irrigated land, but alfalfa and corn became the staple crops.

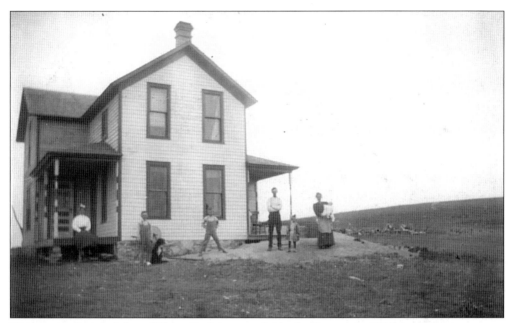

This postcard mailed from White Owl in central Meade County in 1910 carried a message to C.M. Freeman in Butte, Nebraska, identifying the picture on the front as "Frank Atkinson's house."

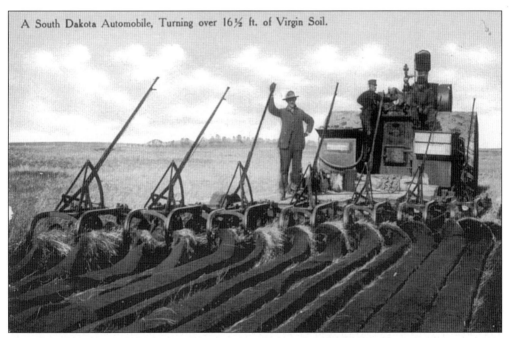

Plentiful rain, new technology, and high prices due to the World War happened to converge soon after the opening of homestead lands in western South Dakota, giving farmers great hopes for the future. In the 1920s, prices fell, rainfall returned to normal and then lapsed into extended drought, and with the exception of irrigated lands around Belle Fourche, many West River farms were abandoned.

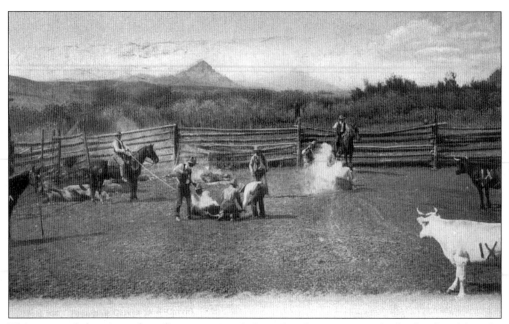

This postcard showing a branding scene carried a printed message on the back advertising the Stockmen's Celebration in Rapid City in April 1909, "the biggest ever."

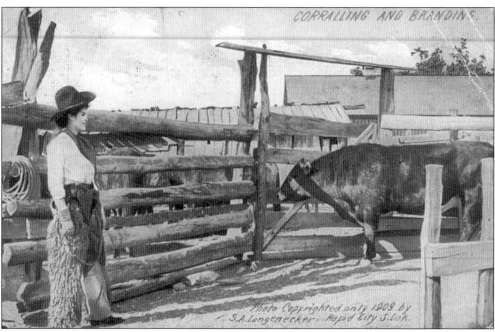

Rapid City publisher S.A. Longenecker produced a series of postcards showing this cowgirl engaged in various ranching activities.

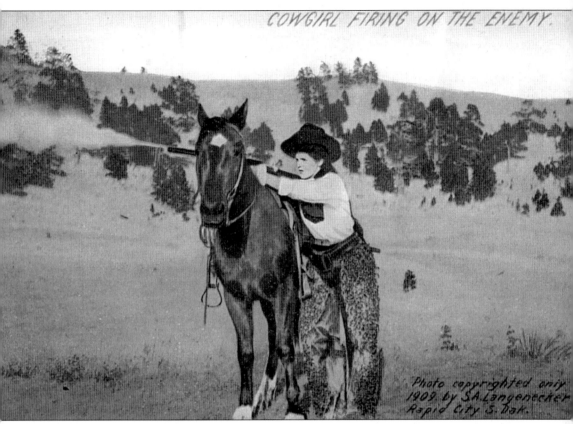

It's not clear what "enemy" this cowgirl is firing upon, but someone in Thunder Hawk chose this card to send a message from "little Edward" to his "Grand Pa" in Waukegan, Illinois in 1911.

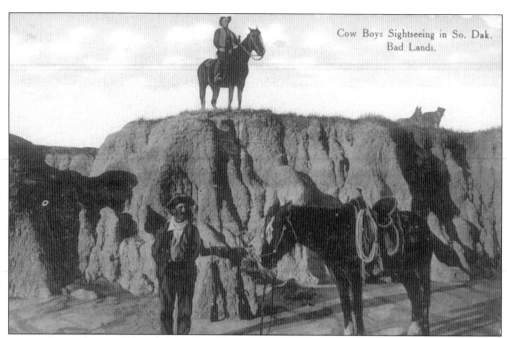

By the 1890s the Badlands were a popular area for cattle grazing, close to the trails connecting Texas and Montana. Homesteaders began fencing off the area after the railroad came through in 1907, and by 1922 nearly half of the land that now makes up the park was owned by homesteaders.

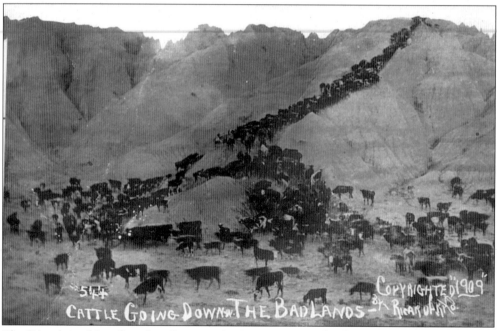

The Ricard Art Manufacturing Company in Quinn, just north of the Badlands, published this photo postcard of cattle in the Badlands in 1909.

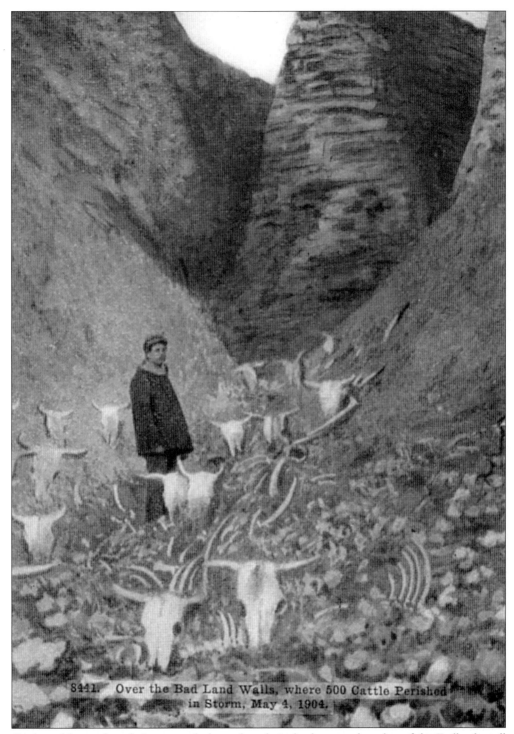

8441. Over the Bad Land Walls, where 500 Cattle Perished in Storm, May 4, 1904.

Cattle and horses lost their way and plunged to their deaths over the edge of the Badlands wall when a freakish blizzard hit the area in May of 1905. The 1904 date printed on the postcard is an error.

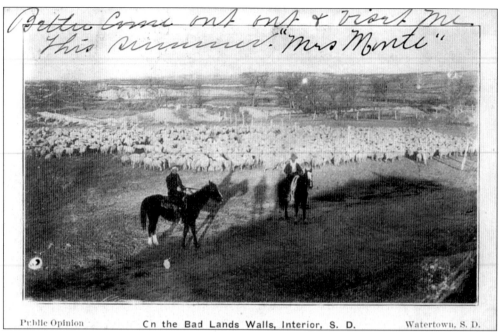

The newspaper office in Watertown published this postcard showing sheep grazing in the Badlands about 1909.

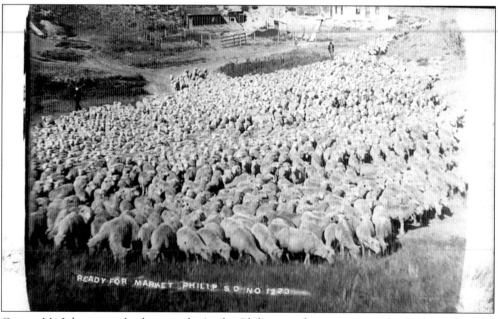

Gustav M. Johnson took photographs in the Philip area for many years, beginning when the town was founded in 1907. He reproduced many of them as postcards, including this one titled, "Ready for Market."

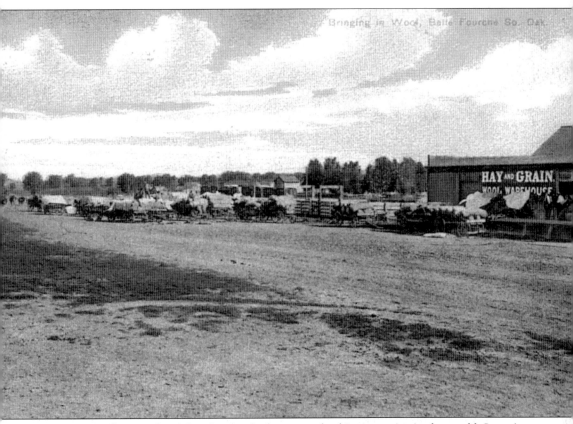

At one point Belle Fourche claimed to be the largest cattle-shipping point in the world. Later it became an important depot for sheep and wool as well.

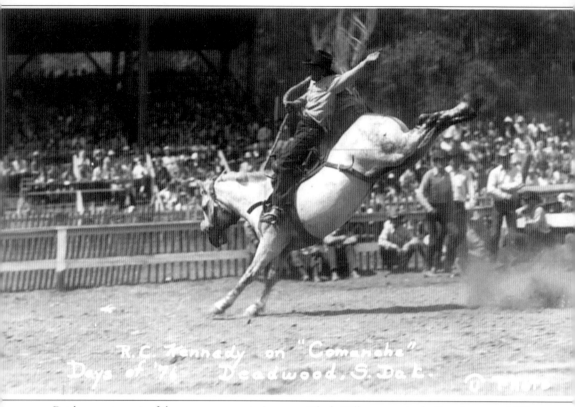

Rodeos were part of the summer events in many Black Hills towns, including the annual "Days of '76" celebration in Deadwood. The sender of this postcard wrote, "This is not me on the horse, not that I wouldn't like to be; but I think the horse might object."

Six
CREATING TOURIST ATTRACTIONS

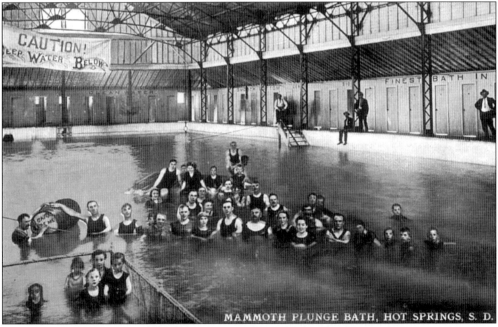

A booklet published by the Hot Springs Commercial Club in 1901 encouraged people to both drink and bathe in the local mineral waters: "Diseases of kidneys and urinary organs, stomach troubles of all kinds, intestinal disorders, skin diseases, asthma, tuberculosis, paralysis, nervous prostration, liver complaint, gout, syphilis, chronic diarrhea, habitual constipation, and other kindred diseases, are here successfully treated."

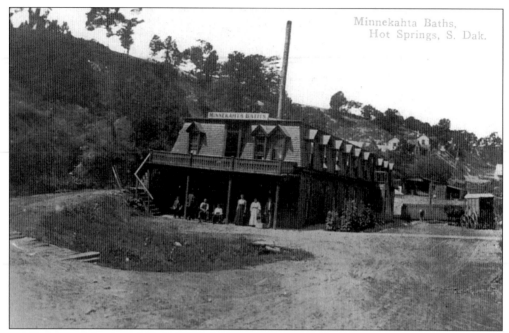

Hot Springs was probably the first Black Hills town to develop specifically around the tourist industry. Mineral baths, spas, and plunge baths along with hotels and other accommodations sprang up in time to be ready for guests when railroad connections were completed in 1891.

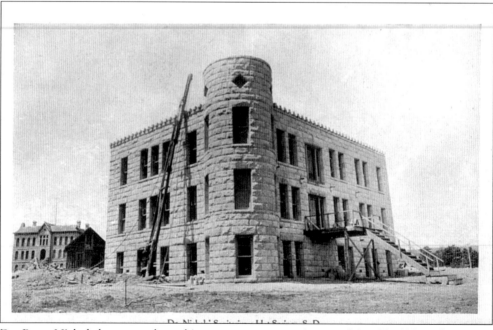

Dr. Perry Nichols began work on his new cancer sanatorium on May 10, 1907. The private hospital on College Hill in Hot Springs opened in 1908.

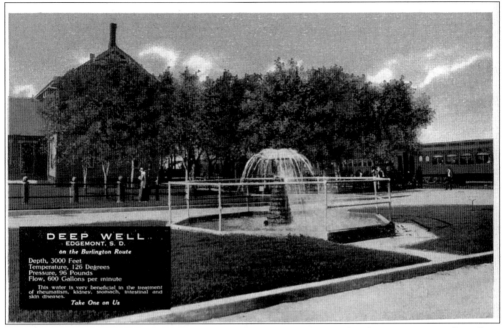

Edgemont tried to attract some of the business from Hot Springs by digging a 3,000-foot-deep well to tap into the warm mineral waters. The Burlington Route published this advertising card that claimed, "This water is very beneficial in the treatment of rheumatism, kidney, stomach, intestinal and other diseases."

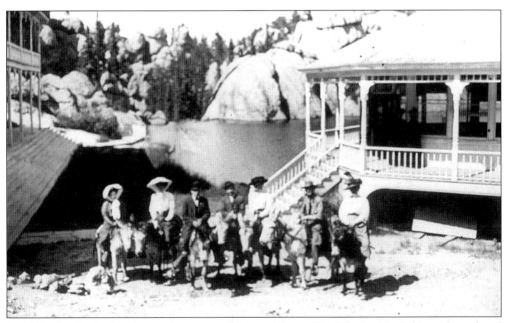

In 1890, the Reder brothers, who operated a sawmill near Rochford, visited this rock-enclosed valley, and envisioned a resort with its own lake. A concrete dam 33 feet high and 40 feet wide was completed in 1892, and in 1893 the Sylvan Lake Lodge opened with 60 rooms. These tourists are ready to start up the nearby trail to Harney Peak.

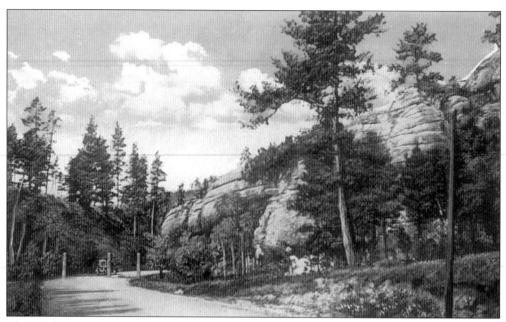

The South Dakota state legislature established a "state game park" in 1913, and through the next several decades park officials consolidated land holdings, reintroduced wild animals to the area, and constructed roads, lodges, campgrounds, and lakes to make the area attractive and accessible to visitors. Custer State Park reached its full level of development through construction projects sponsored by the WPA and CCC during the Depression years of the 1930s.

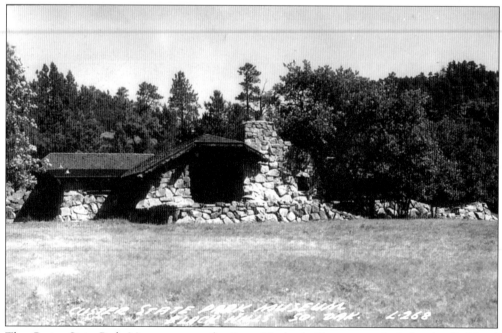

The Custer State Park Museum, now the Peter Norbeck Center, was built by the Robbers' Roost Camp of the Civilian Conservation Corps in 1937.

Man-made Legion Lake received its name from the nearby resort built and operated in its early years by the South Dakota Department of the American Legion.

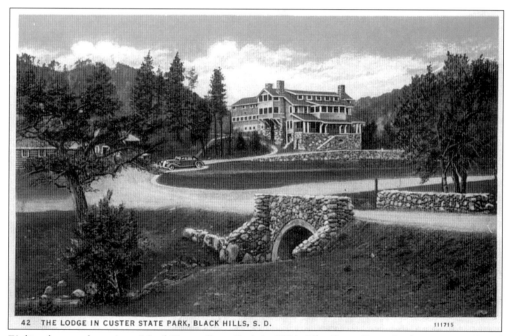

Eighty thousand tourists visited Custer State Park in 1921. The State Game Lodge was completed in 1922 to serve as a resort and park headquarters. It soon proved inadequate for both needs and an addition was added. President Calvin Coolidge used the Game Lodge as his summer residence in 1927, commuting each weekday to offices at the Rapid City High School.

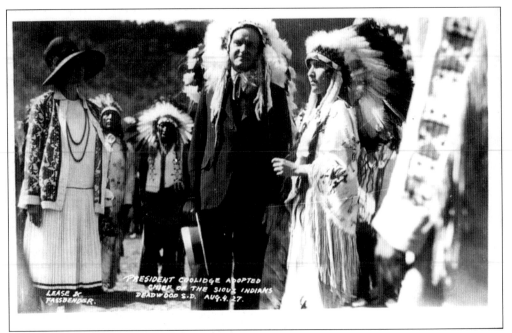

President Calvin Coolidge and his wife Grace spent the summer of 1927 at the State Game Lodge, making them among the most famous tourists to visit the area. At the Deadwood "Days of '76" celebration in August, Coolidge was adopted as high chief of the Sioux tribe and named "Leading Eagle, Wamblee-Tokaha." Rosebud Yellow Robe presented him with his bonnet.

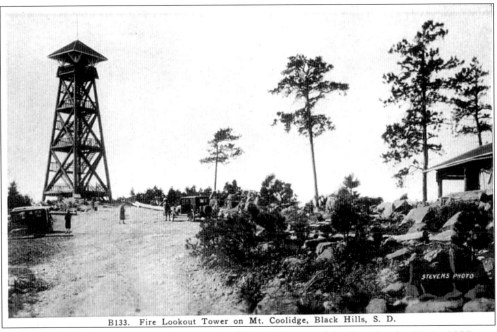

Lookout Mountain was renamed Mount Coolidge in honor of the President's visit in 1927.

The Black Hills gained attention as the site of the Stratobowl, where manned high-altitude balloons were launched in 1934 and 1935. *Explorer II*, launched on November 11, 1935, reached a record height of 72,395 feet, nearly 14 miles, before descending eight hours later and returning to land near White Lake, on the east side of the Missouri River.

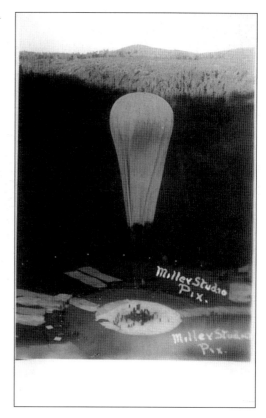

The Cosmos of the Black Hills billed itself as "the most unique Tourist Attraction in the entire Hills."

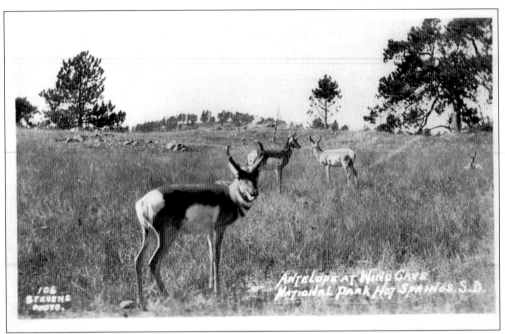

By 1949, Wind Cave National Park included an area of 405 square miles, half of which was enclosed by wire fence. The animal sanctuary held 300 buffalo, 75 elk, 50 antelope, deer, and a protected population of prairie dogs.

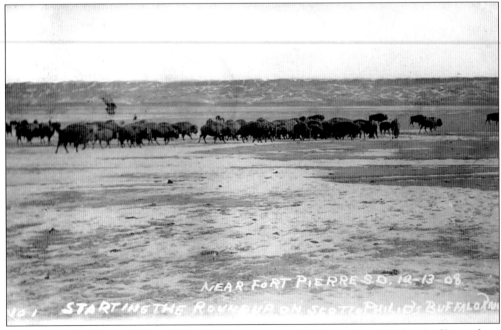

Three years after Scotty Philip died in 1911, state game officials purchased 36 head of bison from his estate and transported the animals by railcar to Hermosa for the new state game preserve. This photo postcard shows Philip's herd at his ranch near Fort Pierre in 1908.

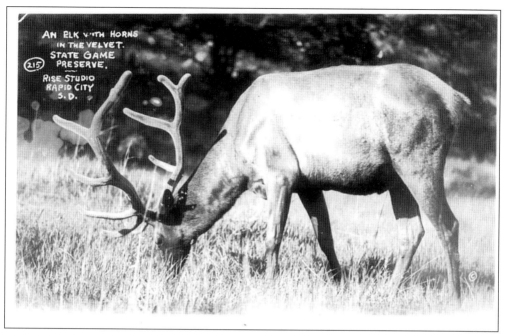

South Dakota purchased 100 head of elk from Yellowstone National Park in 1919 to begin a herd in its Black Hills game preserve, later renamed Custer State Park. In the following years, they purchased mountain sheep and mountain goats from Canada, a bear from Washington, along with moose, beavers, ducks, geese, swans, and Canadian geese.

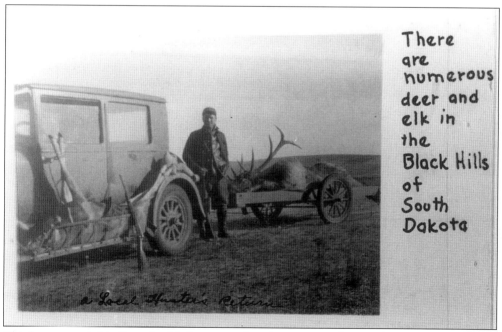

This hunter, probably from the Madison area, found success traveling to the Black Hills to hunt. (Photo courtesy of the SD State Historical Society—State Archives)

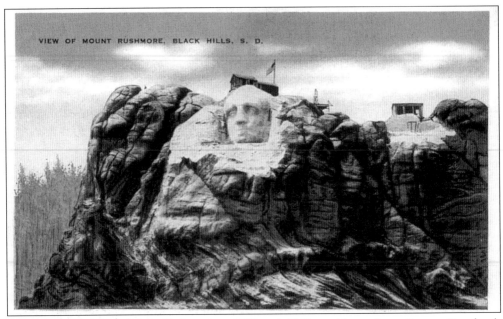

Tourists visiting the Black Hills between 1927 and 1941 could watch as Gutzon Borglum's gigantic carving on Mount Rushmore took shape. This postcard shows the mountain as it looked in the summer of 1930. Carving had started on Thomas Jefferson's head to Washington's right, which had to be moved later, and an inscription panel with "1776" at the top was also underway, which was scrapped to make room for Lincoln.

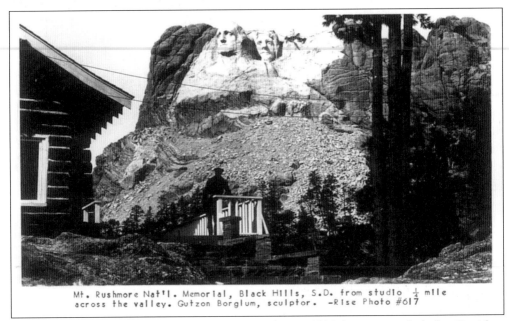

Virginia Ayres visited the Mount Rushmore site in August 1936, just two weeks before President Franklin D. Roosevelt came to dedicate the figure of Thomas Jefferson. She wrote to a friend in Omaha, "Parked right here. Most interesting to watch the work. Have about covered the Hills and so far enjoyed it a lot."

Work on the carving continued through the Depression years, and the Lincoln figure was dedicated in 1937. Federal aid kept the project going after private funds ran out, with the final cost coming in just under one million dollars.

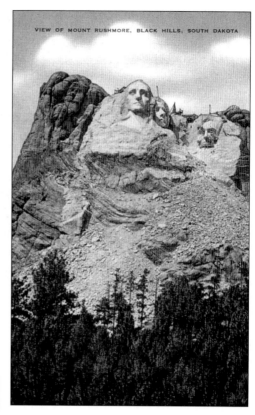

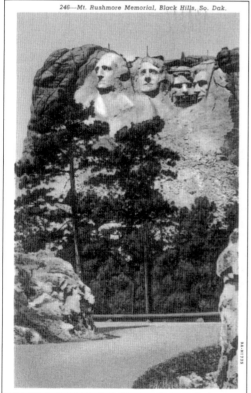

Allen wrote to his Grandma in Michigan in 1941, "I wish you could see this great statue, it's so large and magnificent. The stones that they have carved away are all along the bottom of the mountain."

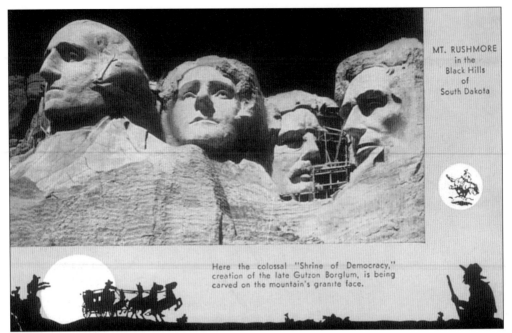

The Burlington Route used Mount Rushmore to advertise its train service to tourist locations in the West: "A thrilling two-day side trip from Newcastle, Wyoming, is the all-expense Black Hills Detour by motor through the heart of this famous region where the glamour of adventurous days in the Old West still lingers."

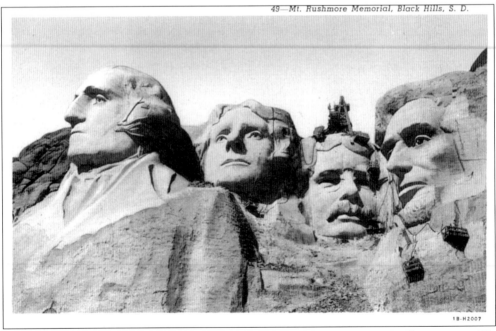

Gutzon Borglum died in March 1941 with the Mount Rushmore Memorial still in progress. His son Lincoln continued work on the sculpture until November, finishing Roosevelt's face and Washington's lapel, after which it was declared complete.

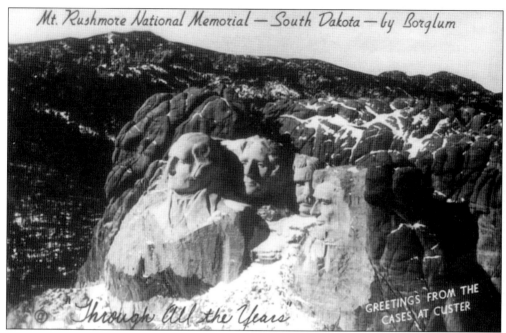

U.S. Senator Francis Case ran the newspaper in Custer and maintained his South Dakota residence at a ranch near there. He used a postcard of Mount Rushmore to send Christmas greetings to constituents in 1951.

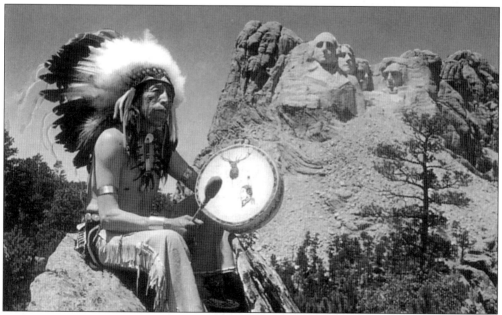

An entire generation of children remembers shaking Ben Black Elk's hand or having their picture taken with him. He seemed to truly enjoy greeting visitors at Mount Rushmore, although it required putting up with some indignities such as the caption on this card: "One of the last of the mighty Sioux, in full dress, beats out his message as he sits at the foot of the Shrine of Democracy."

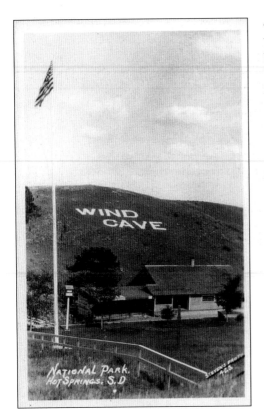

Tom and Jesse Bingham found the entrance to Wind Cave in 1881, and by the early 1890s it became a tourist attraction. President Theodore Roosevelt made the cave a national park in 1903.

This early photo taken inside Wind Cave, postmarked in 1905, shows the Odd Fellows Hall, which included an "all-seeing eye" on the ceiling. Early cave guides also listed a G.A.R. Hall, M.E. Church, Masonic Temple, and W.C.T.U. Hall.

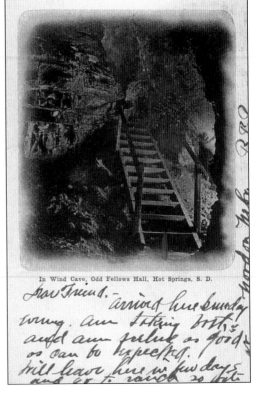

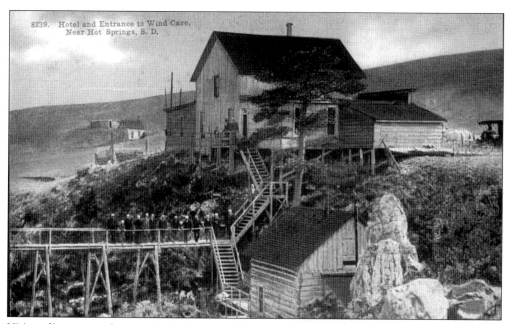
Visitors line up on the wooden bridge near the entrance to Wind Cave in its early years.

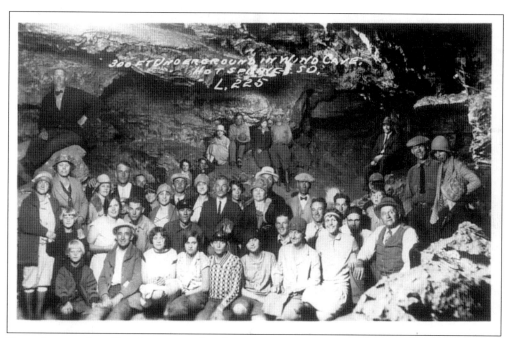
Forty-five people, old and young, gather for a photograph inside Wind Cave in the 1920s.

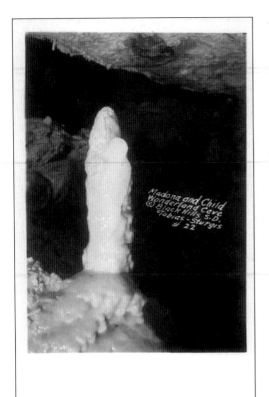

Wonderland Cave opened to the public in 1930, and included formations such as the Frozen River, the Sheep, the Turtle, and the Icicle Fence.

Wild Cat Cave opened in 1940 and claimed to be "one of the largest caves in the Black Hills."

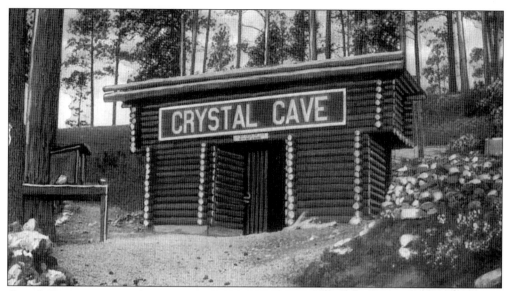

Crystal Cave was a popular excursion stop on the Black Hills and Fort Pierre railroad in the 1890s. An entire room of the cave was knocked out and shipped to Chicago for exhibition at the World's Columbian Exposition in 1893. Years later it was taken over by the Benedictine Fathers, who renamed it Bethlehem Cave, created a Shrine of the Nativity inside, and offered twice-daily masses along with cave tours.

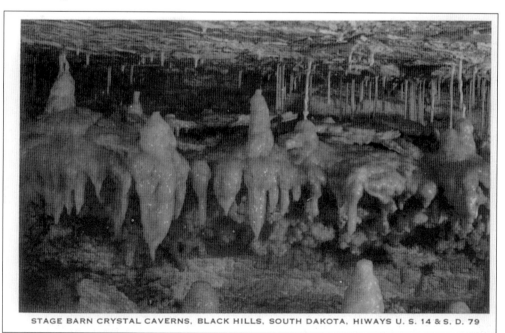

At one time Stage Barn Crystal Caverns distinguished itself from the overwrought claims of other caves by quoting more tentative language from Carl G. Ulvag's thesis, completed at the South Dakota School of Mines and Technology, in its advertising: "It contains formations similar or comparable to those found in any of the other caves in the area and possibly displays several unique features not found elsewhere."

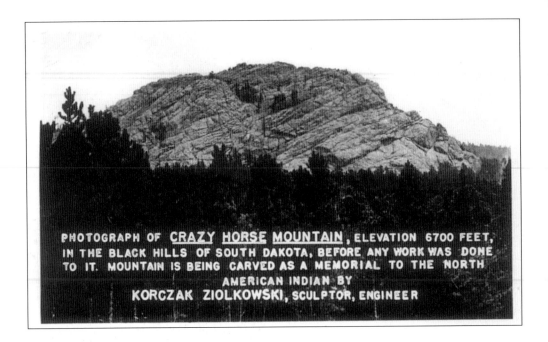

Korczak Ziolkowski worked for a time as an assistant sculptor at Mount Rushmore. He began blasting for his own monumental memorial to Crazy Horse in June 1948. The first admission fee of 50 cents was taken in 1950. In 1951, the sculptor painted a 6-foot wide outline on the mountain, using 176 gallons of paint.

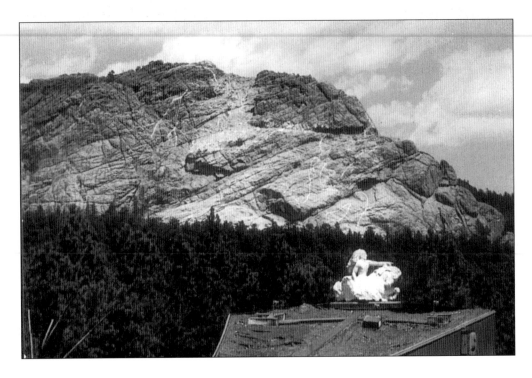

Korczak Ziolkowski's sculpting projects included a head of Crazy Horse cut from the trunk of a Ponderosa pine.

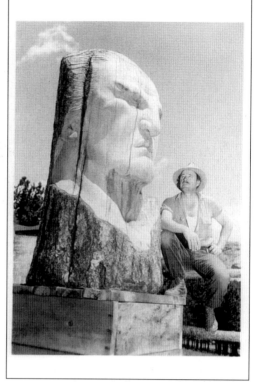

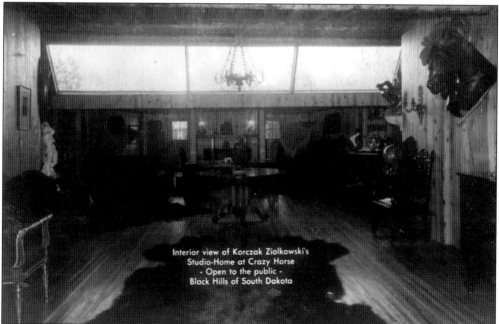

Interior view of Korczak Ziolkowski's Studio-Home at Crazy Horse
- Open to the public -
Black Hills of South Dakota

Ziolkowski's studio and home at the base of Thunderhead Mountain became a tourist attraction in its own right, as his artistic works were collected there along with mementos and gifts left by visitors.

Timber of Ages included a 60-acre tract with huge petrified stumps and long logs from the Minnewasta layer of Dakota sandstone, approximately 100 million years old. Tourists could pay a small admission fee to see displays such as this cord of extremely slow-burning firewood.

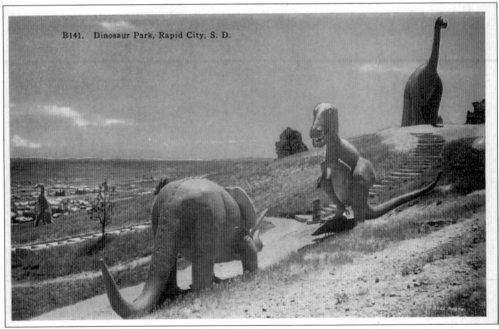

Dinosaur Park, with five life-size reptiles modeled in cement, was conceived by Dr. Cleophas C. O'Harra, geologist and president of the South Dakota School of Mines. The project was sponsored by Rapid City, built with aid from the WPA, and designed by E.A. Sullivan, a Rapid City attorney and sculptor.

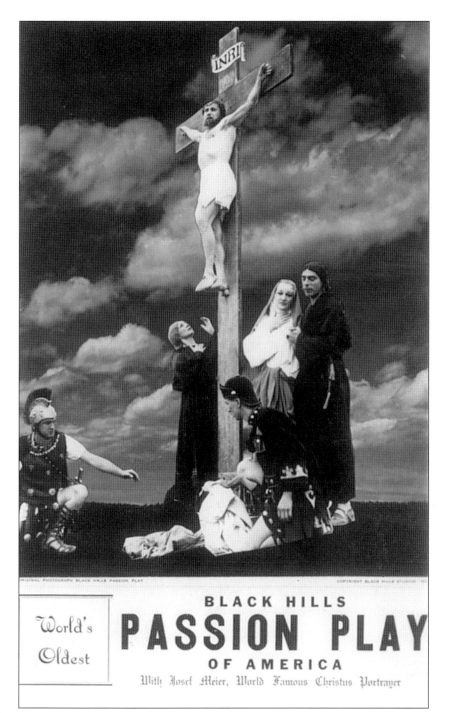

Josef Meier, a seventh-generation participant in the Luenen passion play in Westphalia, Germany, came to America during the Depression and started a similar production that toured eastern cities. The production came to Spearfish in August 1938, sponsored by a group of Spearfish businessmen. In 1939, a hillside theater was built and the company rechristened itself the "Black Hills Passion Play of America."

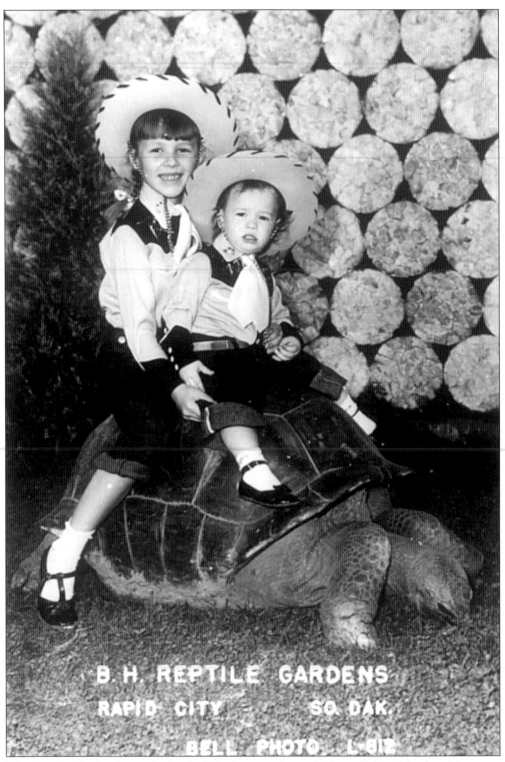
The Reptile Garden featured a herd of 20 giant tortoises, which could be ridden by visitors.

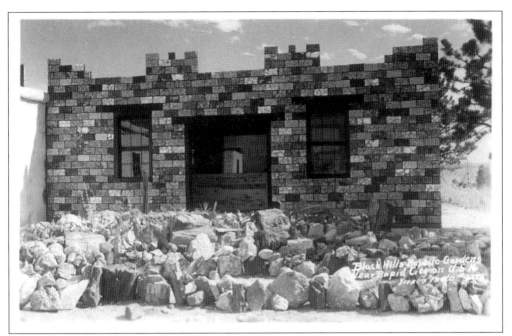

The "world's largest collection of living reptiles" drew tourists to a site just south of Rapid City.

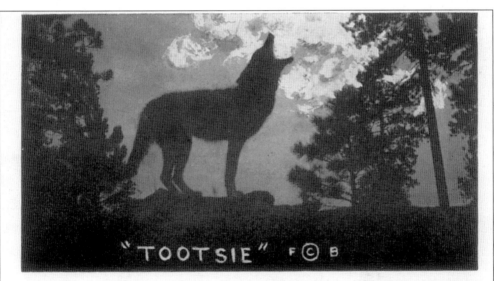

According to Fred Borsch it was his personal pet coyote, not the species, that became South Dakota's state animal in 1949. Tootsie was caught and tamed as a pup by Borsch, who claimed she slept on his bed, and on cold nights, under the covers. She soon gained celebrity in Deadwood and went on a ten-state tour. Tootsie's howl could be heard every evening on a local radio station's weather report.

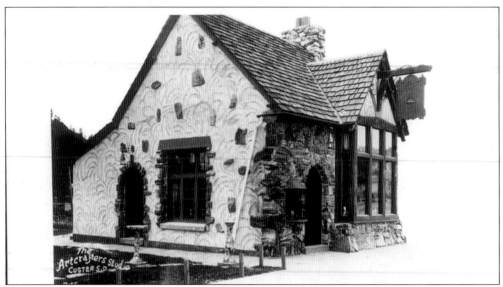

Artcrafters Studio in Custer was one of the first firms to market souvenirs for the tourist trade from local resources. The studio is a fine example of Monte Nystrom's stonework, which can also be seen at the Game Lodge and Museum in Custer State Park, and at the Harney Peak lookout tower.

Monte and Lillian Nystrom covered small clay items with cement and specimens of many-colored pegmatite minerals, including vases, sundials, birdbaths, cigarette boxes, and automobile flower carriers. At one point the Artcrafters Studio employed 30 women and sold souvenirs as far away as Yellowstone and Glacier National Parks.

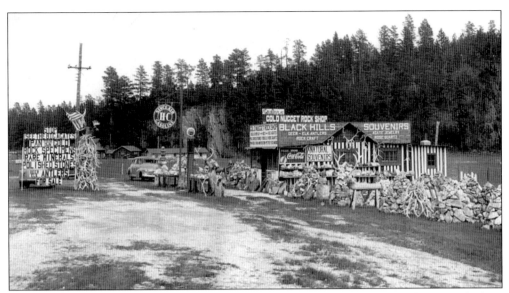

Visitors to the Gold Nugget Rock Shop near Custer could pan their own gold, view displays, and shop for agates, rose quartz, petrified wood, fossils, and antlers, all with no admission charge.

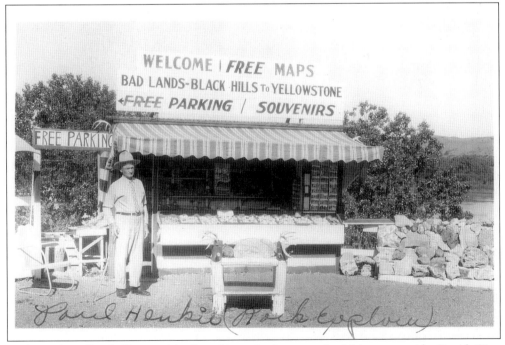

Paul Henke offered "free parking" at his rock shop on the highway outside Rapid City. Displayed on the right side of his stand is a large selection of local photo postcards.

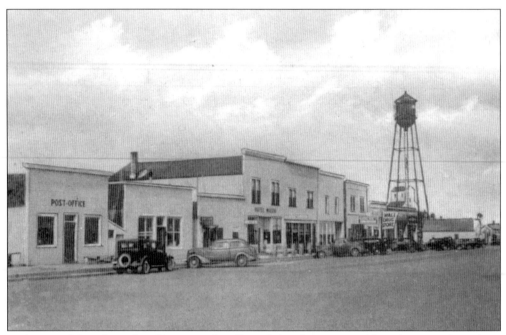

Ted Hustead found out that the town of Wall needed a pharmacy, and bought a storefront there in 1931.

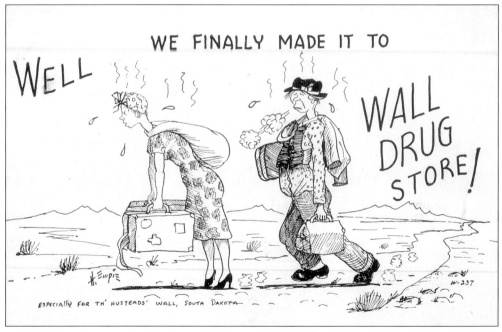

Thanks to an aggressive billboard campaign, starting with "free ice water" signs on the highway in 1936, and eventually leading to signs all over the world, Wall Drug became a destination in its own right.

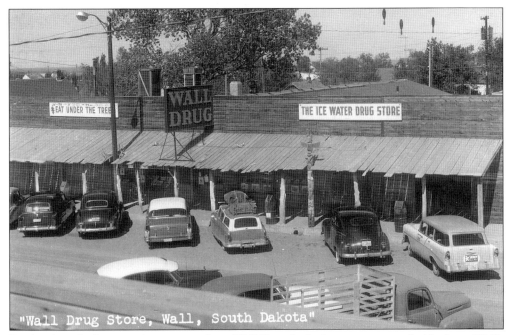

By the time the bottom picture was taken, Wall Drug had taken over most of a block on Wall's main street, and referred to itself as the "Ice Water Drug Store."

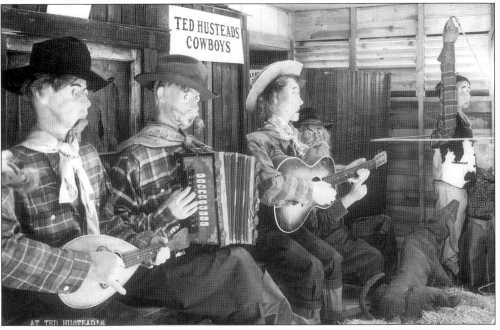

By the early 1960s, Wall Drug had a mechanical Cowboy Orchestra in the front and a Chuckwagon Quartette in the back that played and sang every half hour, plus a bucking horse, a replica of Mount Rushmore, and a covered wagon with live burros as props for tourists taking pictures of their families.

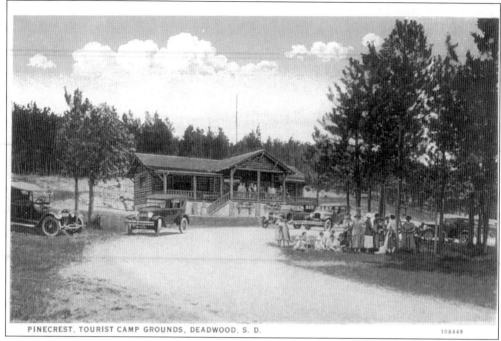

Pinecrest Tourist Camp, two miles outside Deadwood, was owned by the city and provided accommodations for automobile tourists. In 1929, cabins could be rented for 50 cents a night. The log community house had free facilities for all campers, including a fireplace and a room for dancing, and "laundries, shower baths, sanitary toilets, telephone and electric lights."

South Dakota Baptists converted an old sawmill site near Keystone into a summer camp and assembly grounds.

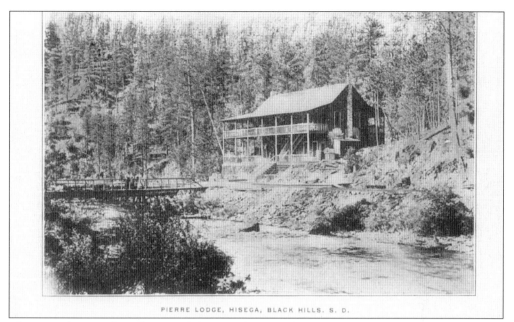

PIERRE LODGE, HISEGA, BLACK HILLS. S. D.

The Crouch Line, formally named the Rapid City, Black Hills & Western, was built by C.D. Crouch to connect Rapid City trains with the Burlington line at Mystic. It quickly became popular for local outings, and one of its stops was directly in front of the Pierre Lodge near Hisega.

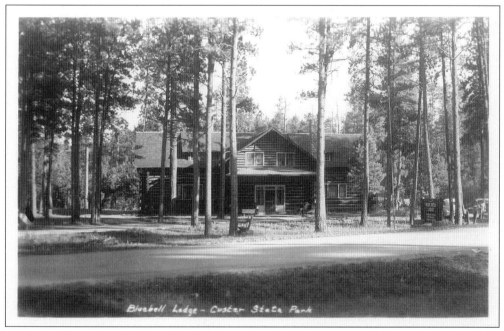

Chris Jensen, an immigrant from Denmark, drove the stage on the line from Sidney, Nebraska to Deadwood, and later established his own stage company running from Hot Springs to Buffalo Gap. He later got into the telephone business, and named the Blue Bell Lodge after the logo of his phone company. CCC workers built a log lodge on the property after Jensen sold it to the state in 1935.

105

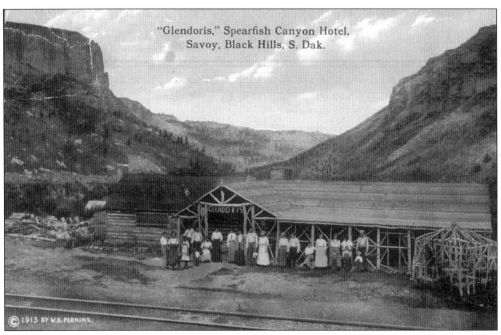

The Glendoris Lodge began as a one-room log cabin built by George Belshaw in the 1890s, which was used as a sawmill office until 1906. Glen Inglis and his wife Dorothy built onto the original cabin and combined their names to create a popular stopping place next to the railroad line in Spearfish Canyon. Ranchers could stop overnight to catch daily trains running to Deadwood and Spearfish.

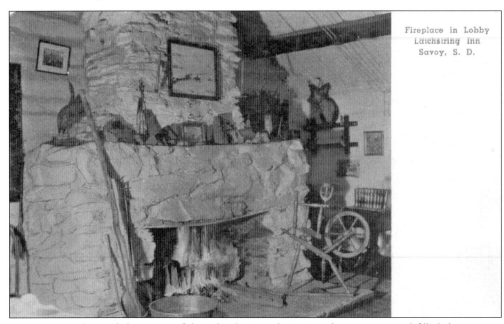

New owners changed the name of the Glendoris Lodge to Latchstring Inn, and filled the interior with antiques, including a spinning wheel "dated 1840," chairs, quilts, a marble top table, gold bullion chest, lady's side saddle, iron tea kettle, bed warmer, and a gun belonging to Calamity Jane.

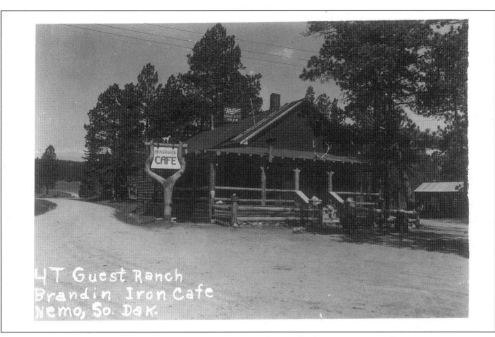

Nemo nearly became a ghost town when Homestake pulled out its sawmill operation in 1939, and most of the residents moved with it to Spearfish. In 1946, a rancher from Martin, Frank Troxell, bought the town to start a dude ranch there. The abandoned Homestake sawmill office became the Brandin' Iron Café, with electric lights made out of wagon wheels and antique lanterns, drapes made of lariat ropes tied into knots, and Troxell's old brand "4T" burned into the back of each chair.

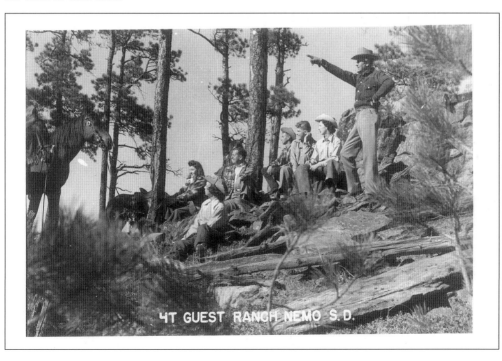

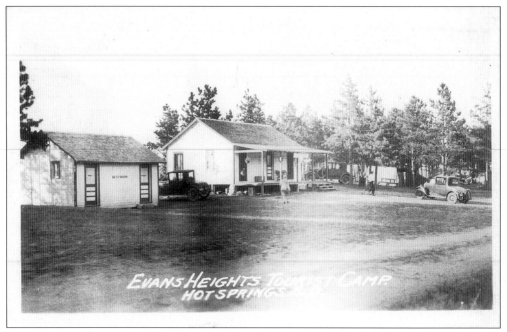

The Evans Heights Tourist Camp provided basic accommodations for early auto travelers. Kenneth reported to Elsie Klapp in Blair, Nebraska on July 26, 1926, "We hit this place today. . . . We will go up to Spearfish Wed. and will start for Yellowstone when we take in all the sights."

Rushmore View Park in Keystone included cabins and an elaborate rock garden.

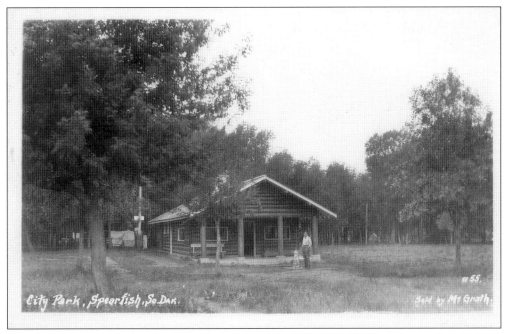

The Spearfish municipal park included an area with cabins opposite the Fish Hatchery, and a separate campground with space for tents and trailers.

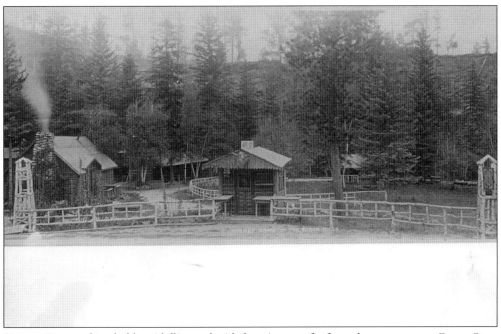

Harney Camp cabins held an idyllic creek-side location not far from the entrances to Custer State Park and Mount Rushmore Memorial.

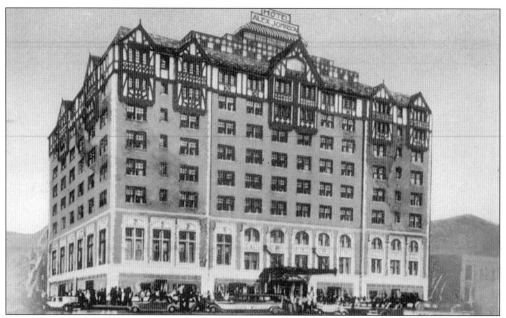

Soon after he claimed a homestead near Doland in 1882, Alex Johnson took a job as a freight handler for the Chicago and North Western railroad. He rose through the ranks to become vice-president of the company in 1920. Johnson built the hotel that bears his name in 1928, and it remains a landmark in downtown Rapid City.

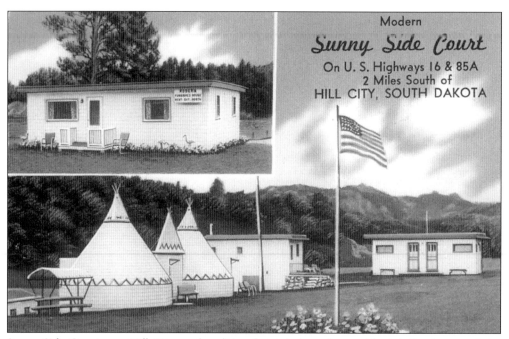

Sunny Side Court near Hill City used traditional tipi designs along with pink flamingos and the American flag to encourage tourists to stop.

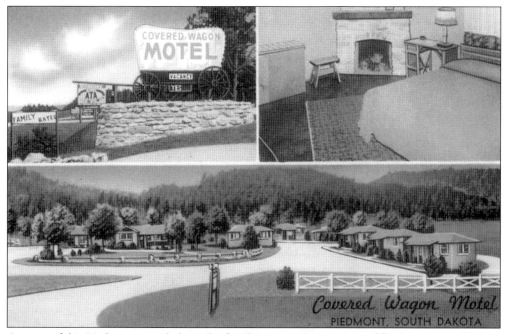

Owners of this Piedmont motel chose the familiar covered wagon motif for their name and sign, but did not go so far as to offer any actual covered wagons for their guests to sleep in.

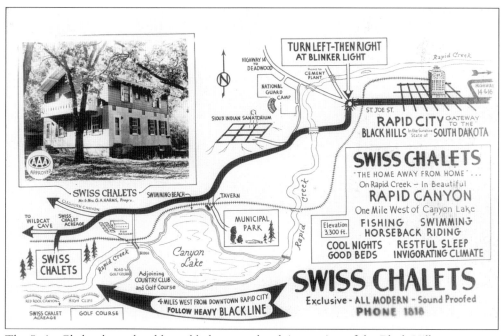

The Swiss Chalets brought old-world charm to the alpine setting of the Black Hills.

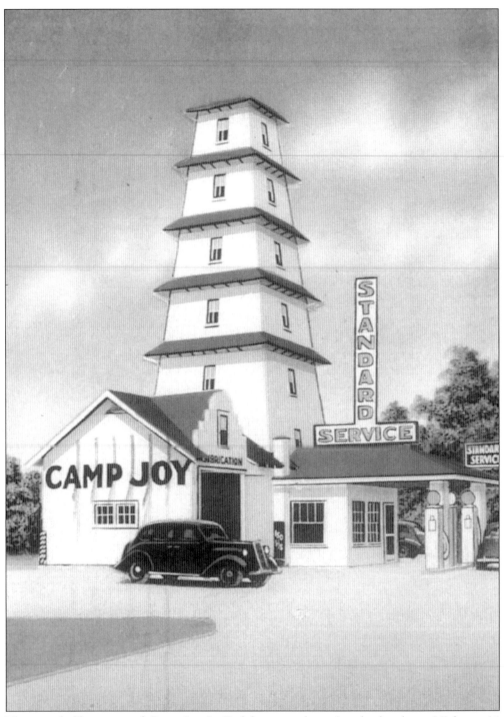

The pagoda-like tower of Camp Joy in Kadoka was a long-time landmark on Highway 16 leading to the Badlands and Black Hills. The Fine and Reaver families wrote to friends in Sterling, Illinois, while traveling in August 1948, "This is where we had dinner Tuesday. It shows one of the very few trees in the area."

Seven
CELEBRATING THE PAST

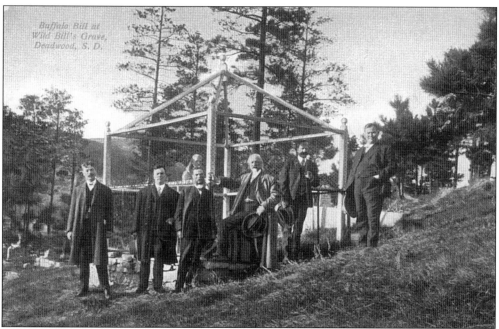

Col. William F. "Buffalo Bill" Cody visited the grave of Wild Bill Hickok in 1906. Hickok had performed briefly with Buffalo Bill's Wild West show in 1874. Hickok's grave was caged in an unsuccessful attempt to prevent tourists from taking pieces of his statue as souvenirs. The mutilated stump was removed to the Adams Memorial Hall in 1955.

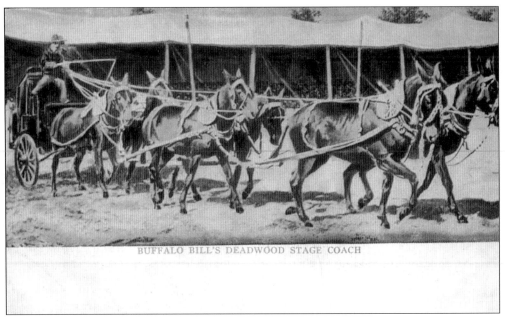

The Deadwood Stage was part of the first Wild West show organized by Buffalo Bill Cody and Frank Carver in 1883. Cody purchased the coach from Luke Voorhees, superintendent and part owner of the Cheyenne and Black Hills stage line. Millions of people saw the stagecoach being held up by Indians and rescued by Buffalo Bill in performances in many U.S. cities and in Great Britain, France, Italy, and Germany.

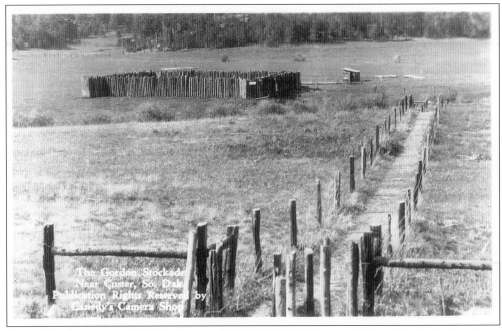

One of the first groups of gold seekers to the Black Hills built a stockade at this site in the winter of 1874-1875. Citizens of Custer rebuilt the stockade as a tourist attraction in 1925, and it was rebuilt again in 1941 by a Civilian Conservation Corps team from Camp Narrows.

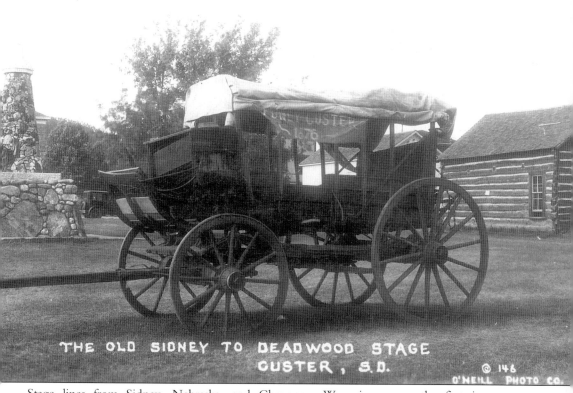

Stage lines from Sidney, Nebraska, and Cheyenne, Wyoming, were the first important transportation and communication links to the Black Hills. In this photo, the Sidney stage was on display in Way Park outside the Custer County courthouse. Behind the stage in the photo is the Ross Monument, dedicated to H.N. Ross who discovered the first gold on the Custer Expedition in 1874, and the first cabin to be built in Custer in 1875, which had been moved to the park and turned into a museum.

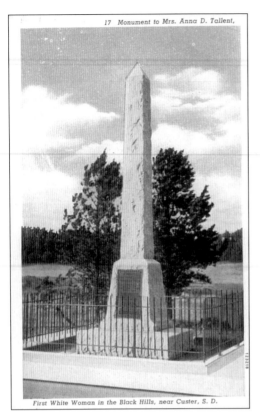

17 Monument to Mrs. Anna D. Tallent,
First White Woman in the Black Hills, near Custer, S. D.

Annie D. Tallent arrived in the Black Hills in December 1874 with her husband and nine-year-old son. She was long identified as the "first white woman in the Black Hills," although in recent years that honor passed at least in part to Sarah Campbell, an African American woman who accompanied the Custer Expedition earlier that year.

J.H. Riordan sculpted this life-size statue of Rev. Henry Weston Smith, the first preacher in the Black Hills, who was killed only a few weeks after his arrival in August 1876. Dedicated in 1891, the monument on Smith's grave in the Mount Moriah Cemetery was soon hacked to pieces by memento hunters.

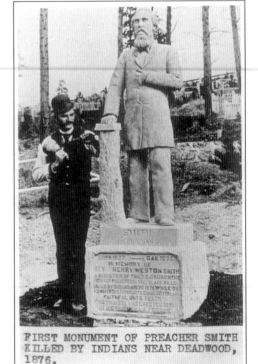

FIRST MONUMENT OF PREACHER SMITH KILLED BY INDIANS NEAR DEADWOOD, 1876.

REV. H. W. SMITH.

Seth Bullock, the sheriff of Lawrence County, was instrumental in arranging for this monument to his long-time friend Theodore Roosevelt, whom he first met when Roosevelt visited Deadwood in 1884. Roosevelt lived on a ranch near Medora from 1883 to 1886. The tower was built on a mountain renamed Mount Roosevelt, from which it was possible to see into four states.

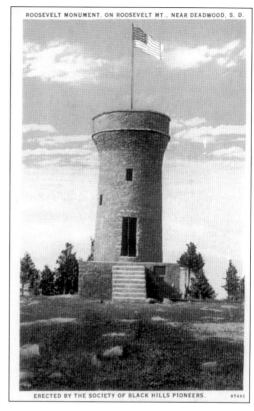

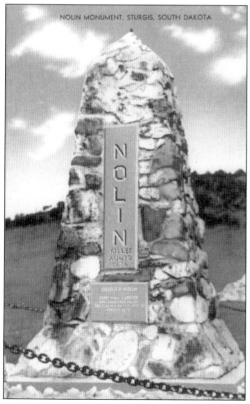

Before regular postal service was available in the Black Hills, private carriers delivered letters for 50 cents each, with half the fee going to the carrier and half to the post office. While carrying mail to Deadwood in August 1876, Charles Nolin was killed near Deadman Creek, south of Sturgis. A monument made from local rock was dedicated at the site in 1932.

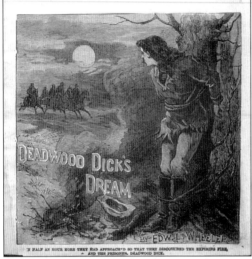

"Deadwood Dick" was a dime-novel character created by author Edward L. Wheeler. Later, several Deadwood residents took up the title. Richard Clarke, an old-time Black Hills resident, took on the name, the role, and the costume starting with the "Days of '76" celebrations in the 1920s, and his mythical presence continued after his death when his cabin and nearby grave were added to the tour guides as a historical site.

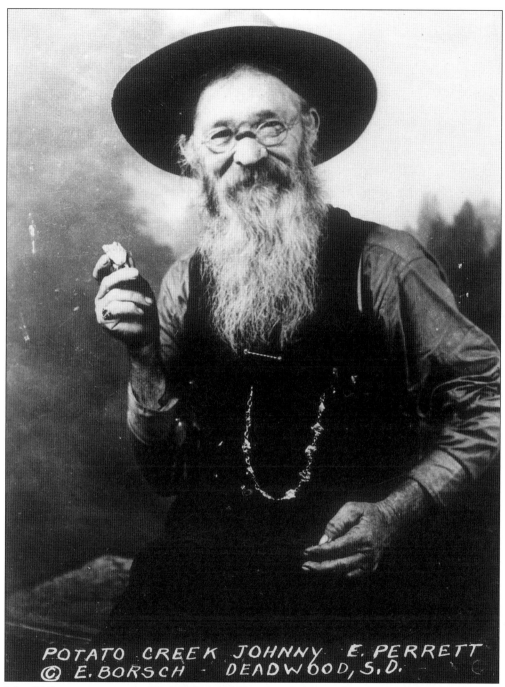

POTATO CREEK JOHNNY E. PERRETT
© E. BORSCH - DEADWOOD, S.D.

John E. Perrett came to the Black Hills in 1883 and settled in a cabin on Potato Creek where he panned and sluiced for gold for many years. In 1929, he brought a huge nugget into town, and although his tale about finding it has been disputed, Mildred Fielder's description of the gold nugget as a "real whopper" covers all variations of the story. Johnny is pictured holding his nugget. W.E. Adams bought it for $250 for his new museum just being built. Potato Creek Johnny appeared for almost 20 years in the "Days of '76" parade in Deadwood, until his death in 1943.

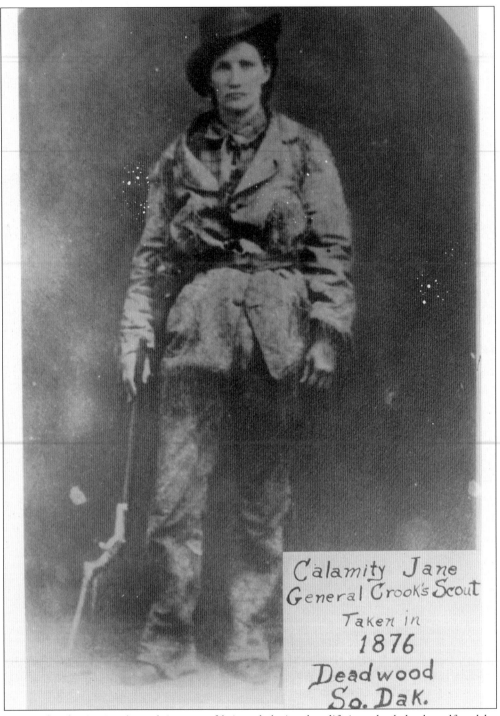

Many of Calamity Jane's exploits were fabricated during her lifetime, both by herself and by others, including the information added to this photograph. Among the few agreed-upon facts are that she arrived in Deadwood around the same time as Wild Bill Hickok in the summer of 1876, and in 1903 she was buried beside him in Mount Moriah Cemetery.

Poker Alice's biography places her and her husband Warren G. Tubbs at the gaming tables in Deadwood in 1876, but her obituary says that they did not arrive until the 1890s. She was "never famous in any way until the pioneer days had passed and the recent years had created a great deal of interest in some of the so-called characters of the west." In 1910, she moved to a house near Sturgis, but returned to Deadwood periodically as an attraction at the "Days of '76," until her death in 1930.

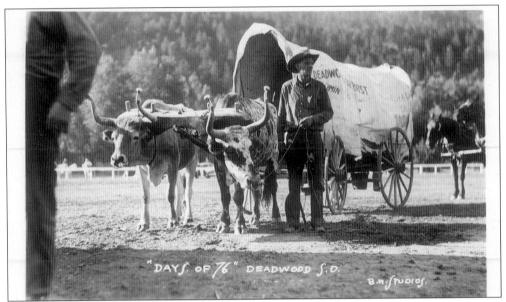

By the 1920s, Deadwood was an industrial and commercial center, with solid brick buildings and civic-minded citizens. Town promoters decided to recreate Deadwood's "wild west" past programmatically in the annual summer festival of "Days of '76," which featured parades, contests, and exhibitions. Local citizens restaged important historical events including Indian raids, the shooting of Wild Bill Hickok, and Deadwood's first wedding.

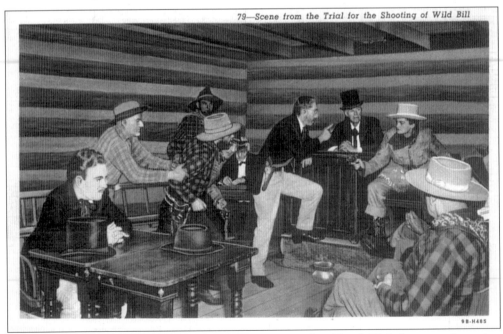

Reenactment of the trial of Jack McCall for the murder of Wild Bill Hickok was performed as part of the "Days of '76" celebration in 1924. Later taken over as a private production, by the late 1930s it became a regular show every summer in Deadwood with a cast of local residents, college students, and teachers.

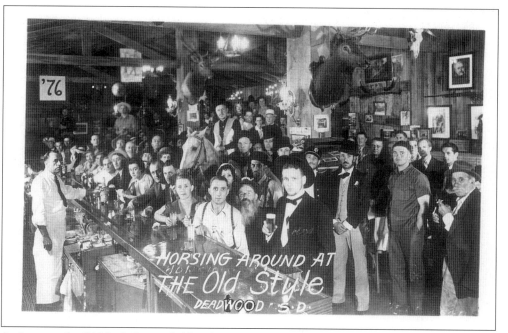

A picture at the Old Style Bar probably taken during the "Days of '76" shows portraits of Calamity Jane and Poker Alice enshrined on the wall, and the real live Potato Creek Johnny sidling up to the bar. The Old Style advertised itself as "the only museum in the world with a bar."

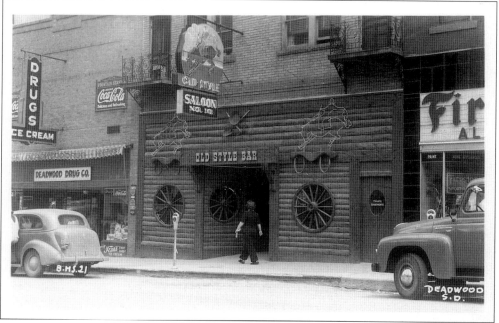

Downtown Deadwood in the 1950s looked like most small towns of the period. The Old Style Bar, located on the site of the original Saloon No. 10 where Wild Bill Hickok was shot, kept the memory of Deadwood's Wild West past alive by displaying a shovel, pick, and gold pan on a log false front with a neon bucking bronco and wagon-wheel windows.

By 1939, the Adams Memorial Museum in Deadwood reported 150,000 visitors a year. According to the 1930 dedication program, the museum funded by local grocer W.E. Adams would "perpetuate a glorious record of progress, telling a picturesque story of human and often superhuman hardihood. It will preserve concretely for all time the history of the Black Hills, the last Frontier of Western America."

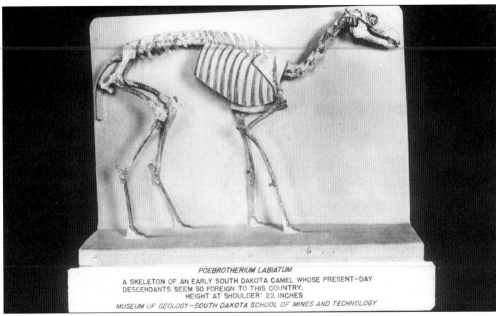

C.C. O'Harra established the Museum of Geology as an integral part of the South Dakota School of Mines. Rocks and fossils collected from the Black Hills and Badlands quickly gave it a reputation as one of the finest geological museums west of the Mississippi River. One of the museum's early prize specimens was this fossil skeleton of a prehistoric camel.

The Sioux Indian Museum got its start with artifacts collected by John A. Anderson, photographer and long-time resident of the Rosebud reservation. The museum opened in Rapid City's Halley Park in 1939 under sponsorship from the Indian Arts and Crafts Board of the U.S. Department of the Interior.

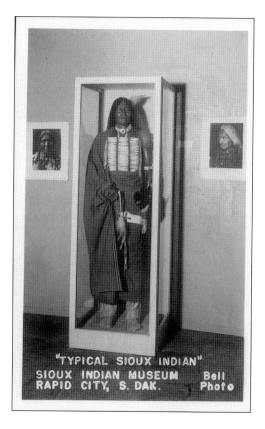

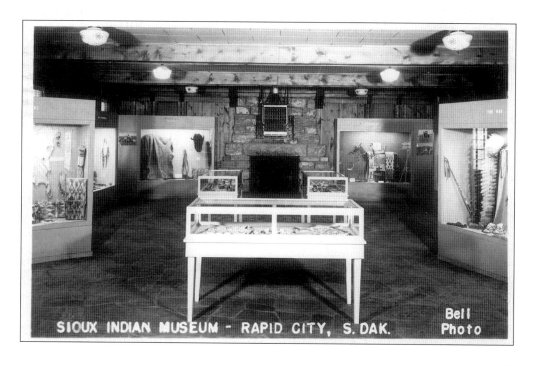

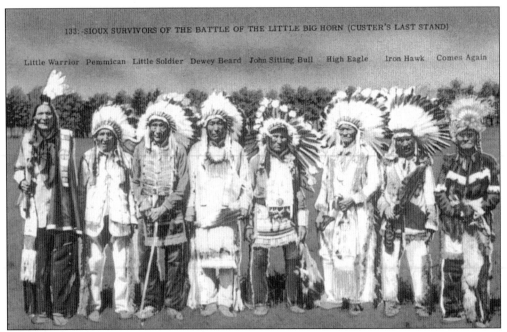

Lakota survivors of the Battle of the Little Big Horn in 1876 gathered for a reunion in Custer State Park in 1948, where this picture was taken.

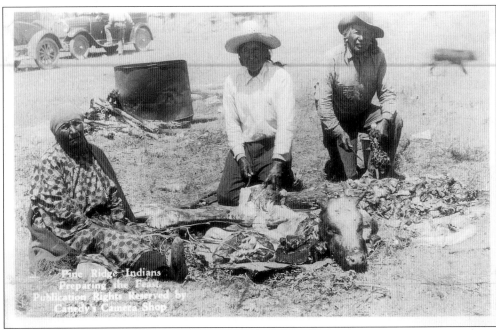

This commercial postcard shows a somewhat more realistic view of life on the Pine Ridge reservation. Lakota people participated in the "Days of '76" and other summer festivals, but remained isolated from most of the happenings in the Black Hills through the first half of the 20th century.

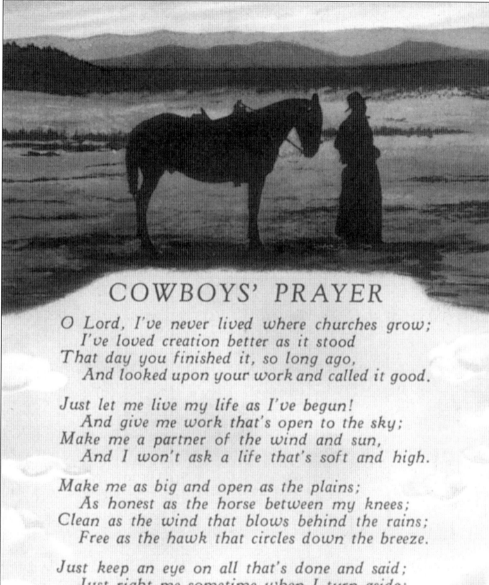

COWBOYS' PRAYER

O Lord, I've never lived where churches grow;
 I've loved creation better as it stood
That day you finished it, so long ago,
 And looked upon your work and called it good.

Just let me live my life as I've begun!
 And give me work that's open to the sky;
Make me a partner of the wind and sun,
 And I won't ask a life that's soft and high.

Make me as big and open as the plains;
 As honest as the horse between my knees;
Clean as the wind that blows behind the rains;
 Free as the hawk that circles down the breeze.

Just keep an eye on all that's done and said;
 Just right me sometime when I turn aside;
And guide me on the long, dim trail ahead—
 That stretches upward towards the Great Divide.

 Author Unknown

Badger Clark, South Dakota's first Poet Laureate (or "poet lariat" as Governor Leslie Jensen put it) was both pleased and annoyed that his most famous poem was often attributed to "Anonymous." Glad to know that his work was appreciated, Clark wrote, "Mr. Anonymous has written some marvelously good things in the past and when a man reaches a height where he is identified with Anonymous, that's success." Clark lived much of his life in a cabin inside Custer State Park.

SELECTED BIBLIOGRAPHY

Many local histories and guides were consulted in the writing of this book, but unfortunately they cannot all be listed here. The books listed below contain extensive historical photographs of the Black Hills and Badlands region, and will provide a good start for those who would like to explore this topic further.

Fielder, Mildred. *Railroads of the Black Hills.* Seattle, Wash.: Superior Publishing Co., 1965.
———. *Wild Bill and Deadwood.* Seattle, Wash.: Superior Publishing Co., 1964.
Josephy, Alvin, Jr. Black Hills, *White Sky: Photographs from the Collections of the Arvada Center Foundation, Inc.* New York: Times Books, 1978.
Lee, Bob. *The Black Hills After Custer.* Virginia Beach, Va.: Donning Company, 1997.
Lee, Bob, ed. *Gold, Gals, Guns, Guts.* Deadwood-Lead '76 Centennial, Inc., 1976.
Parker, Watson, and Lambert, Hugh K. *Black Hills Ghost Towns.* Chicago: Sage Books, 1974.
Progulske, Donald R. *Following Custer.* Brookings: Agricultural Experiment Station, South Dakota State University, [1983?].
Progulske, Donald R. *Yellow Ore, Yellow Hair, Yellow Pine: A Photographic Study of a Century of Forest Ecology.* Brookings: Agriculture Experiment Station, South Dakota State University, 1974.
Rezatto, Helen. *Tales of the Black Hills.* Rapid City: Fenwyn Press, 1989.
Strain, David F. *Black Hills Hay Camp: Images and Perspectives of Early Rapid City.* Rapid City, S.Dak.: Dakota West Books & Fenske Printing, 1989.
Toms, Donald; ed. *The Gold Belt Cities: Deadwood & Environs: A Photographic History.* Lead, S.Dak.: G.O.L.D. Unlimited, 1988.
Toms, Donald. *The Flavor of Lead: An Ethnic History.* Lead, S.Dak.: Lead Historic Preservation Commission, 1992.
Toms, Donald D.; Schillinger, Kristie L.; and Stone, William J., eds. *The Gold Belt Cities: City of Mills: A Photographic History.* Lead, S.Dak.: Black Hills Mining Museum, 1993.
Toms, Donald; Stone, William J.; and Motchenbacher, Gretchen, eds. *The Gold Belt Cities: Lead & Homestake: A Photographic History.* Lead, S.Dak.: G.O.L.D. Unlimited, 1988.